S0-BSL-927

Composing your paintings

Composing
your paintings

Bernard Dunstan

Studio Vista London

General editors Brenda Herbert and Janey O'Riordan
© Bernard Dunstan 1971
Published in London by Studio Vista Limited
Blue Star House, Highgate Hill, London N19
Set in 9 on 9$^1/_2$ pt Univers
Printed and bound in Holland by
Drukkerij Reclame, Rotterdam
SBN 289.79747.0

Contents

WITHDRAWN

Can composition be learned?

The word 'composition' simply means 'putting together'. Everything we make, whether it is a symphony, a novel, a table, a ship, a picture or a meal, has to be put together and consciously 'composed'; the parts, in other words, must be shaped and related to one another and to the whole.

So the idea of composition is really inseparable from the idea of making. A book on the composition of pictures becomes a book on painting; almost everything will come into it sooner or later.

This is why the slightly forbidding air that the word has for many people, as if it were a special and rather difficult subject, is unfortunate. Amateur painters have sometimes said to me 'Of course, I've never learnt about composition', implying, almost, that there is a set of rules to be learnt and applied. It is dangerous, although tempting, to isolate the different aspects of painting from one another. We tend, for example, to talk about colour by itself, when really it cannot be separated from tone and shape. Similarly there is a temptation to consider the design of a picture as if it were part of a system that can be applied, once mastered, to any purpose and any subject.

The more one goes on painting, the more one has to admit that the truth is very different. Painting cannot be divided up into its constituent parts. Everything in a picture that looks as if it could be taken out and examined as a subject by itself turns out to be dependant upon, and modified by, many other factors.

Perhaps one can only learn about composition, as one can only learn about colour, by actually making pictures — lots of them — and getting to grips with the problems as they turn up. Still, it helps to know about the possibilities. And I don't mean 'rules'. There is no point in learning sets of rules and recipes and then trying to apply them. This is much more likely to stifle the fresh and direct reactions that are the basis of all successful painting. What we learn about composition, as about colour, should always be aimed at concentrating and strengthening these responses, by giving them a formal articulation.

The painter who 'doesn't know anything about composition' is still, inevitably, composing, when he sits down to paint even the simplest subject. He cannot put down one shape or line onto an empty canvas without creating a composition of sorts. But his very limited sense of placing and design is likely to be dominated by stereotyped ideas, often the sort of negative instructions

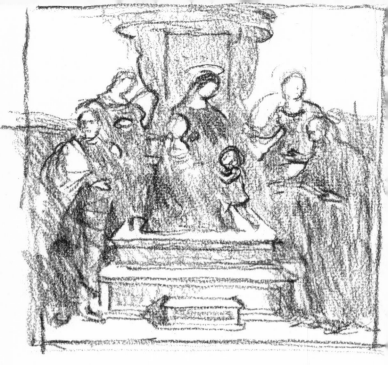

Fig. 1 Drawing after *Madonna and Child with Saints* by Raphael

that people remember vaguely from schooldays: 'don't put the main subject in the middle', and 'rules' of that sort. What we can try to do is to think about the business of composition — not in order to find out how to do it, but simply to become more aware of the possibilities, so that the way is opened for greater variety in our approach to picture-making.

Artists of every period develop their own ways of putting pictures together, to suit their own purposes. It all depends on what you are painting *for*. This is why comparing composition with learning the grammar of a language is misleading. A knowledge of English grammar can be applied to a political speech, to a workshop manual for a car mechanic, or to a funny story. The rules of sentence construction, the use of verbs and clauses, will apply in each case with equal rigour. But if we take three equally varied, and equally valid, pieces of pictorial design, such as a religious painting, a strip cartoon, or an abstract decoration, you can see at once that each subject demands its own 'grammar'.

8

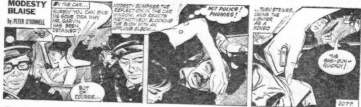

Fig. 2 A strip cartoon

Raphael's *Madonna and Child with Saints* (fig. 1) is a cen-
tralized composition, and this gives a restful, stable feeling, in
keeping with the tender and yet solemn nature of the subject. The
grouping round the architectural central axis (the axis of a form is
the imaginary line running through its centre) of the canopy and
steps is quite symmetrical, but every figure has a subtle bend or
twist which prevents any monotony. A picture of this sort is also
very 'readable'; it is instantly comprehended, even by the most
untutored eye. This is important when one remembers that it has
another function besides decoration — that of teaching the
doctrines of the Church.

The second example (fig. 2) is in complete contrast. This tells
a story in a highly sophisticated way. Before this particular
century, and before the development of the film, it would have
been very difficult to unravel its meaning at all. Each part leads
onto the next, and the action moves from left to right, from me-
dium shot to close-up. Extreme contrasts of scale are handled
with ease. Wording is included as part of the design.

Finally, the abstract decoration (fig. 3) returns us to a more
stable form of design. This uses a balance created by colour as
well as tone (the lightness or darkness of an area) to keep the
semi-geometrical shapes in equilibrium. The design is wholly on
the one picture plane — depth is not exploited, and there is, of
course, no story or human theme. Obviously a composition like
this depends to a very large extent on the relationships of colour.

Fig. 3 An abstract decoration

These are three totally different forms of visual art, all of which are using one or other form of composition for their particular ends. These ends could be described, rather crudely, as decoration and story-telling. Decoration covers all the abstract and formal properties of a work of art; story-telling covers the content, the subject matter, the themes that are dealt with. I don't want to suggest that these elements can be weighed out separately, like flour and sugar. However, I think you will agree that our first example, the *Madonna and Child* by Raphael, could be said to strike a fairly even balance between content and form, while of the other two examples the strip cartoon is essentially to do with story-telling (though even here there is an element of pleasing pattern on the page), while the abstract is entirely a formal statement.

In this book we shall be dealing almost entirely with paintings which belong to the central realistic tradition of European art, and hardly at all with the extreme ends of the spectrum, which stretches from illustration at one end to complete abstraction at the other.

Even within the main tradition, there are a multitude of different attitudes towards composition. Let's look at a few more examples. All these kinds of picture-making, at one time or another, have been systematized into a set of formulae that could be used by any artist of the period to produce a reasonable result. This codification, or making into systems, of various design-styles generally happens when the style itself has become established and past its first freshness. Each period develops its own way of putting a picture together for its particular purposes, and when this way has been in general use for a time it will become accepted as 'the way to compose a picture'.

Fig. 4 is a Byzantine mosaic. This is certainly the most rigid and basic of all design-formulae — the figures are arranged in a straight row, and are all seen full-face. This is not because the artists of the period couldn't do anything else. It was accepted as a necessary and powerful way to symbolize earthly and religious power.

Next, a typical piece of high-Renaissance design, worth comparing with the other Madonna (fig. 1). This circular composition by Raphael (fig. 5) moves right away from the symmetrical and

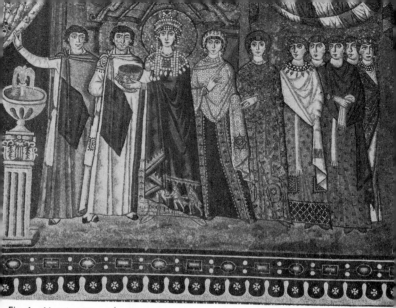

Fig. 4 Mosaic of Empress Theodora, Church of S. Vitale, Ravenna. Mansell Collection, London

uses strongly-contrasted axes and rhythmically-arranged twists and diagonals to create a powerful tension between the forms, making a closely-knit and compact design. This kind of composition has been used ever since as an academic formula.

Fig. 5 Drawing after Raphael

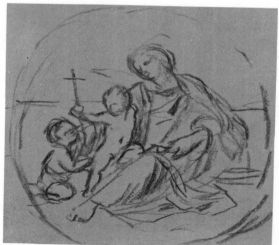

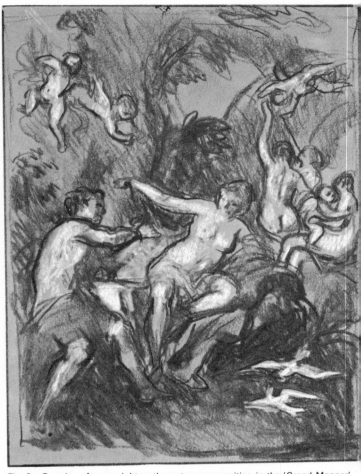

Fig. 6 Drawing after an eighteenth-century composition in the 'Grand Manner'

Next, an example of the academic 'Grand Manner' of the eighteenth century (fig. 6).

This kind of thing is obviously a natural development from the masters of the Italian Renaissance, and uses the same language of rhythmic and contrasting movement from one form to another. It becomes frankly decorative and cliché-ridden, until it can be reduced to a set of rules. Academic teachers were able to develop

Fig. 7 Drawing after landscape by Richard Wilson

precepts, such as that a well-designed figure painting should have a main group and a secondary one; that there should be a certain proportion between the dark areas and the light ones; that the main figure or figures should not be exactly in the middle of the picture; that a pyramidal form of construction is one of the useful ways of building up a group; that the general colour of a picture should be warm, rather than cold; and so on. You can find the most intelligent and sensitive statement of the academic approach to picture making in Reynolds's *Discourses*.

The equivalent in landscape is the 'picturesque' view of the eighteenth century, which essentially stems from Claude Lorraine (see fig. 71). This drawing after Richard Wilson (fig. 7) shows many of the characteristic features of the picturesque landscape: the big mass on one side, and the 'way through' to a distant horizon; the figures grouped on the foreground plane.

The Claudian landscape was turned into a formula by innumerable drawing-masters. Such great English watercolourists as Cozens and Cotman spent a good deal of their careers teaching amateurs and young ladies how to turn out landscapes, and books were produced with examples for them to copy.

13

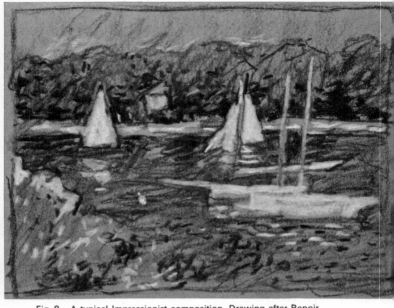

Fig. 8 A typical Impressionist composition. Drawing after Renoir

The nineteenth century realist movement, culminating in Impressionism, was a revolt against academic procedures that had become stale. The ironic thing is that the typical Impressionist way of building a picture (fig. 8) has now become so much part of our way of seeing that it, in its turn, has become a formula – one which most beginners and amateurs are encouraged to follow. The Impressionist 'system' is not so much a matter of principles of construction or design as an attitude towards painting on the spot, and the close observation of colour and tone.

These, then, are a few of the ways of composing pictures which have become crystallized and made into methods which could be taught. Of course any of these idioms, however much they may have been systematized, can still be used with conviction. There is no form of expression that can't be revitalized by an artist who really believes in it and finds it suitable for his purposes.

What can we learn from the attitudes towards composition, and the systems that have been evolved, of the past? It all depends on the sort of painting that we want to do. If this is one of the modern idioms, there may be very little connection between it and the sort of attitudes that I have been talking about. Some recent developments have resulted in a breakdown of the picture surface, so that composition – indeed, painting itself – no longer

14

has any meaning in relation to them. I am purposely avoiding any attempt to deal with non-figurative art in this book. Someone who wants to work in a way so far removed from the tradition of European art of the last four centuries won't be very likely to read a book of this sort anyway; and there is a very large number of artists, including amateurs and students, who continue to find a traditional use of a figurative idiom more fruitful and positive.

All figurative artists are, in one sense, using the same language. If they have nothing else in common, they will at least all be working on a two-dimensional flat surface and saying things on it about the three-dimensional solid world around them. Apart from the more extreme modern developments, every picture, whatever its aims or style, can be said to have certain things or needs in common if it is going to be a stimulus and a contentment to the eye.

These needs can be summed up by two words: unity and variety. Although these terms may seem to be opposite in meaning, a picture, like any other satisfactory construction (for example a bridge, a motor car, or a symphony) has to combine the two.

Unity is necessary because without it our minds and eyes are worried by disorganized muddle. Some shape and pattern has to be imposed; things have to 'hang together'. On the other hand, without variety, our second need, our eyes quickly become bored and lose interest.

Traditional recipes and methods attempt to create interesting compositions by the use of differing proportions of unity and variety, and different ways of achieving them. As we have seen in the examples (figs 1-8), a Byzantine mosaic artist is not afraid of monotony, indeed he needs a degree of it to strike the appropriate chord of majesty; while an eighteenth-century picturesque landscape artist is at some pains to create as asymmetrical an arrangement as possible.

As long as we remember that the form of a picture must always, to a large extent, be determined by the subject matter and what is being said about it, we can learn a lot from the attempts of innumerable artists and writers to systematize principles of composition.

But don't take any rules or principles too seriously. The composition of your picture should, in my opinion, develop from your own involvement with the subject – from inside, not from outside.

Some aspects of composition

Fig. 9

In spite of what I said earlier about the danger of separating the various aspects of painting a picture into compartments and dealing with them as if they were parts of a machine, I am going to find it necessary here to look at the various elements which can go to make up a picture separately. These are the linear framework (which includes divisions of area) and proportion; tonal structure and pattern (that is, the way areas of light and dark are arranged); shape; colour, rhythms and movement; and repetition. We shall, as it were, hold them up and look at them for a moment; and then, as quickly as possible, return to a consideration of the whole picture.

The linear framework

Probably most people, if they think of an analysis of the composition of a picture, will visualize a diagram showing a network of lines and diagonals, curved and dotted, by which the structure and emphasis of the design are represented. And there is good reason for this. Whatever else can be jettisoned from a picture — the colour, the handling, the tonal structure — in the end one will be left with simple, irreducible shapes represented by lines.

This is only half the story, however, and it only applies to a certain kind of painting (though most of the pictures by old masters that we are familiar with can be analyzed fairly usefully in this way). A picture is not, after all, made up of lines, but of patches of colour of differing intensity and tone. Its composition, then, must be related all the time to this colour and tone, and not thought of as a web of lines and linear shapes that are arranged, and later 'filled in'. A linear pattern can be completely altered by

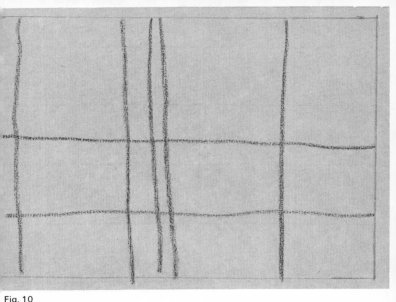

Fig. 10

the modification of tones or colours, as can be seen in fig. 9, where a network with a strong emphasis in one direction is altered radically when tone is added.

This must be remembered in relation to everything that follows about linear design and spacing.

I have already talked about the fascination with geometry which characterized the thinking of artists of the Italian Renaissance. We can be sure that Holbein, Leonardo and Dürer were also expert at geometry. In modern times, Seurat and Degas are notable for their revival and use of Renaissance geometrical systems, such as the Golden Section.

This is the best known system of proportion, and deserves a closer look, for it has been used by innumerable artists, designers and architects.

I should point out, perhaps, that vertical and horizontal divisions of a rectangle constitute the simplest and most basic way of arriving at a composition. If I draw a random series of such divisions, as in fig. 10, I have straightaway created a basis for a composition, one that can be developed in all sorts of ways.

It is useful to develop the ability to trace an imaginary grid like this when looking at pictures, or when observing actual scenes. This can help a lot in making the eye more sensitive to subtle relationships of placing and distance. Obviously many interiors and landscapes can be related to a grid like fig. 10.

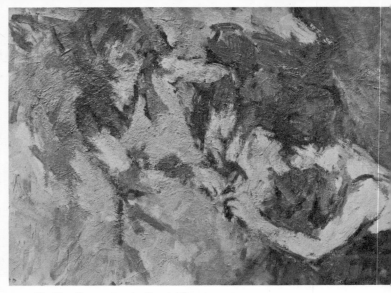

Fig. 11 *Dressmakers* by Bernard Dunstan

Fig. 12

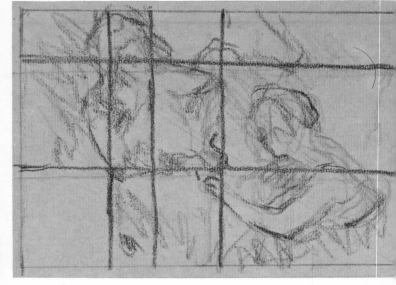

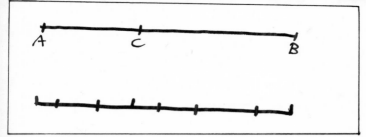

Fig. 13

Even in a picture which hardly contains any straight lines going across the rectangle, such as fig. 11, the idea of a vertical—horizontal grid can still be valid; thus you can regard the main forms of this picture as being placed on divisions of the rectangle like those in fig. 12.

So the way that the picture rectangle is divided, vertically and horizontally, is likely to be an important factor in the design of many different types of picture. The Golden Section system can be summed up as a way of making divisions and sub-divisions of a line or a rectangle without ever repeating yourself.

I will try to explain this simply. If I take a line, AB, and divide it at C in the Golden Section proportion (very roughly 5 to 8), each section can then be divided in the same proportion again and again, as in fig. 13, and none of the resulting lengths will be the same.

The same thing can be done with a rectangle. Fig. 14A shows a Golden Section rectangle, the sides being roughly in the proportion of 5 to 8. A curious thing happens if we divide this rectangle by making a Golden Section division, EF, along the longer side. We are left with a square, and yet another Golden Section rectangle standing on its end, FCBE (fig. 14B).

Fig. 14A Fig. 14B

Fig. 15A Fig. 15B

This one can then be similarly divided, and the process can go on ad infinitum, all the squares and rectangles being of different areas (fig. 15B).

Obviously all this has something useful to do with unity and variety, and it is easy to see how the use of this proportion has helped many painters avoid monotony when dealing with complex compositional problems.

The Golden Section is the only proportion that has these properties, out of the infinite number of possible ways of dividing a line or a rectangle. In other words, when it is divided, the smaller bit bears the same relation to the bigger piece as the bigger piece does to the whole (fig. 15A).

This in itself is rather odd, and there are other strange facts about this proportion. It seems to crop up all over the place, from Georgian windows to plant growth, in natural forms as well as in design.

However, what matters to us here is the way in which it has been used in designing actual paintings. I can't do better than to take a couple of pictures, one by a Renaissance and one by a more modern master, and see how the same system of proportion has been used — quite consciously, I should imagine — by both of them.

Seurat's *Bridge at Courbevoie* (fig. 16) is a most beautiful and complex construction, in which the mathematical basis never becomes over-obvious or oppressive. This is very successfully synthesized with the direct observation and strong feeling for the character of a place and the light that falls upon it which characterizes Impressionist landscape. You can see from the diagram (fig. 17) how the whole design is based on a grid of Golden Section divisions. Most of these can be measured from a point at which two shapes cut one another — for instance, the foliage at

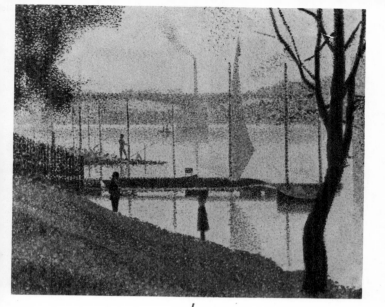

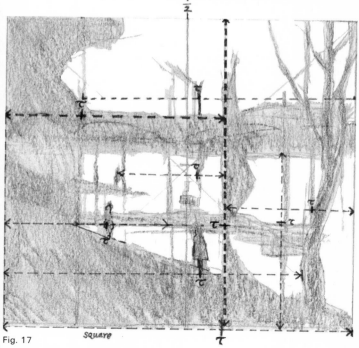

$\frac{1}{2}$

square

Fig. 17

Fig. 18 Drawing after *Flagellation of Christ* by Piero della Francesca, showing division by 'rabatment'

the top left corner where it cuts against the horizon. There is hardly a single vertical shape in the picture that cannot be related in this way, either to another one or to the edge of the canvas. Yet there is no suggestion of a merely grid-like composition. This is partly achieved by Seurat's extremely sensitive use of diagonals and curves, like the tree on the right and the large sail.

There are many other subtleties of design: notice, for instance, that the elbow-like bend in the tree-trunk brings a section of it into a direction which makes exactly a right-angle with the diagonal of the river bank. The bank itself is given a kink just before it meets the trunk, which lets it run up against the upright part of the trunk at another right-angle (see page 42). The line of the bank itself is very subtle and varied in its quality of edge.

This simplified drawing of Piero della Francesca's *Flagellation of Christ* (fig. 18) shows the main features of the composition. It is an enigmatic picture with a strange quality of stillness about it, which is no doubt intensified by the severe mathematics of its construction.

Though there are many Golden Section divisions to be found in this picture — for instance, the head of Christ comes exactly on one of them — there are others, as so often in Piero's pictures,

St Marceau

Fig. 19

which can't be pinned down. The relationship of square to rectangle, shown in the big division of the picture area, is very deceptive and subtle.

Of course it would be very unwise to assume that because a picture is full of Golden Sections it is necessarily well designed; or indeed that any position in a rectangle is necessarily better than any other. However, the point is really that a consciousness of the various ways of making divisions and intervals will make one just that little bit more sensitive to the way that this can happen in nature. Practically any subject that we can think of entails some division of the surface — the horizon of a landscape, the walls and doors in an interior, and so on.

An example of the way things seem to space themselves naturally is shown in this drawing of a row of trees (fig. 19).

This shows the subject 'just as it happened'. But the fact that it was drawn with a very conscious awareness of the shapes and sizes of the intervals between the tree-trunk means that this aspect has been given its full value. Someone drawing exactly the same scene who was unaware of this feature might well understate it slightly. The difference might be very small; but such small distinctions can be crucial.

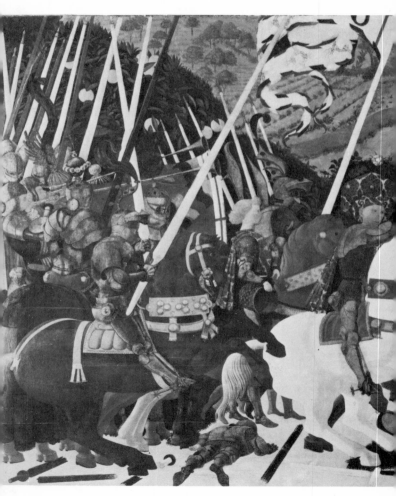

Fig. 20 *The Battle of San Romano* by Uccello. National Gallery, London

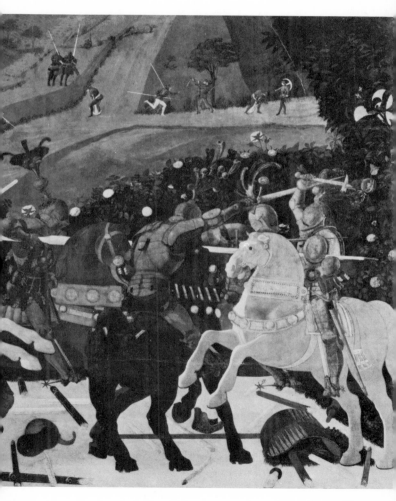

Fig. 21 Drawings after Piero della Francesca and Degas

I have gone into the Golden Section proportion at some length, because it is easily the best-known method of division. Cutting the rectangle into a square and another rectangle, as we saw in fig. 14B, can of course be applied to a rectangle of any proportion. It is known, technically, as the 'rabatment' of a rectangle. Here are two examples (fig. 21).

It will be seen that the square within a rectangle forms a comfortable and secure division, on which a prominent shape might well be situated.

Two such divisions can be made so that the squares overlap

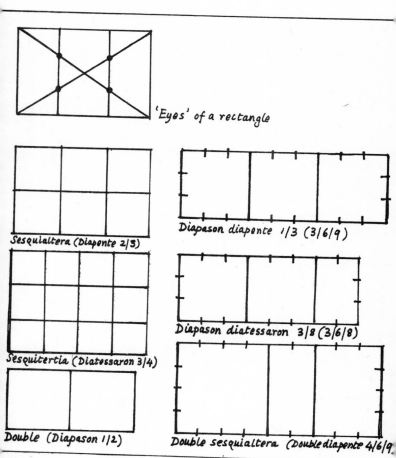

'Eyes' of a rectangle

Sesquialtera (Diapente 2/3)

Diapason diapente 1/3 (3/6/9)

Sesquitertia (Diatessaron 3/4)

Diapason diatessaron 3/8 (3/6/8)

Double (Diapason 1/2)

Double sesquialtera (Double diapente 4/6/9)

Fig. 22

each other (fig. 22). If the diagonals of these squares are drawn, the resulting points are known as the 'eyes' of the rectangle, and some writers have thought them to be particularly telling points in the format; a dubious idea, but perhaps worth mentioning.

I have also illustrated in fig. 22 a number of other and more esoteric methods of dividing space, all of which have been used at some time or another. I will admit to including them largely because of a partiality for their splendid names.

27

Tonal structure and pattern

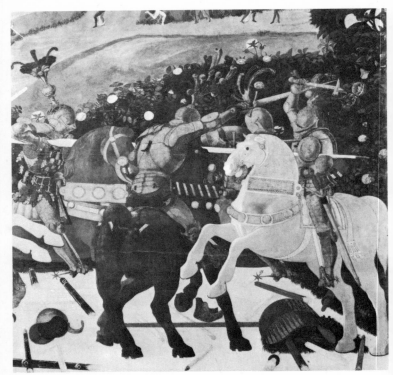

Fig. 23 Detail of *The Battle of San Romano* by Uccello. National Gallery, London

Let us start this section by looking at a detail of the picture on page 24, Uccello's *Battle of San Romano*. This is a great painting by any standards, but what I want you to examine particularly is the character of the shapes that Uccello makes.

If you paint lively, interesting shapes like these, with such vigour and charm, it hardly seems to be a question of deciding where to put them. The picture will work, and the composition will take its shape, out of the energy of the shapes themselves and their relationships. One might add that in the same way a lot of dull and inert shapes will produce a dull picture, however carefully they are composed or grouped.

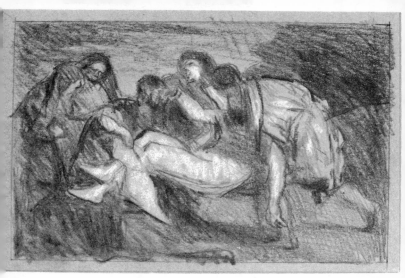

Fig. 24 Drawing after *The Entombment* by Titian

In the Uccello there is a marvellous feeling for variety of shape and size. There is a continual change from small, complicated pattern to large and simple silhouettes. And there is not a shape which doesn't have a feeling of springiness and vigour. This goes as well for the spaces between things. Look at the silhouetted objects against the light ground (turn back to page 24 to see the whole picture). The spaces enclosed by these dark shapes are all as interesting as the things themselves. Where the dark and the light horse meet, over on the right hand side, there is a passage where their front legs overlap and come against a lance and a piece of armour on the ground. The light shapes of the ground here are a very good example of what I mean.

The drawing after Titian's *Entombment* (fig. 24) shows tonal shapes which are larger, more serene, and more connected, as is suitable for the mood of the picture.

A drawing of this kind can be of real help in understanding the importance of the tonal structure of a picture. It is a good thing to get into the habit of working with a few tones (this example uses about four gradations of dark, plus a white, on a middle-toned paper). Allow similar tones to connect together, while emphasizing the contrast between different ones which meet, such as the man's bent back against the trees on the right.

29

Fig. 25 The same subject altered in character by the way the tone is treated

It is easy to get confused about colour and tone, but in fact there can be no colour without some degree of lightness or darkness. Even a painting by Matisse or Bonnard, in which the colour may appear to play a dominant part, can be seen to be very satisfactory in tonal design when reduced to a black and white photograph (fig. 26).

Two things help in the impression of richness and liveliness which this painting by Bonnard transmits, even without the help of colour. One is the quality of the shapes themselves; the other is the sense of richness given by the arrangement of dark, light and middle tones.

Shapes can, quite apart from their descriptive function, be lively, passive, powerful or elegant, stationary or full of movement. The shape of an area of tablecloth in a picture by Bonnard can be full of unexpected charm (fig. 26) and completely worthy of being called imaginative or inventive art, in spite of the fact that it is a description of something that exists.

I nearly wrote 'simply' a description; but the fact is that to paint something seen is not at all the simple affair that it may seem to be, or which it is assumed to be by admirers of an art which no longer has connections with the world and with ways of interpreting it.

Even when he thinks he is being most objective and direct, the painter is making, almost unknown to himself, all kinds of subtle changes in the shapes he is dealing with. The relationships of several shapes, for instance, can be half instinctively modified towards greater separation or greater connection (fig. 25), according to the needs of the picture; and this may be done without making any change in their actual position, but largely by means of slight adjustments in their tonal relationship.

30

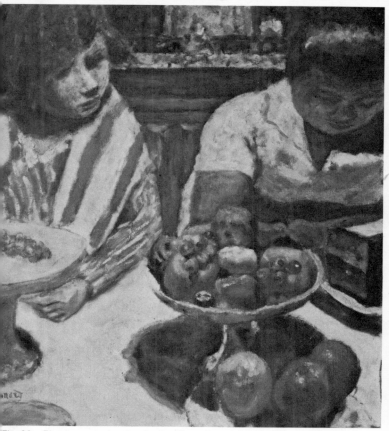

Fig. 26 *The accounts for the day* by Pierre Bonnard. Photo Royal Academy, London (Collection M. François Pacquement)

Every shape in the Uccello (fig. 20) has a sharp, precise quality. The curves have an almost whip-like clarity. In contrast, the shapes in the painting by Bonnard (fig. 26) may appear almost muffled, but in fact they are every bit as exact in their drawing. They have to 'carry' a quite different sort of colour – a subtly-varied, iridescent, glowing colour which echoes and merges across from one area to another – and the quality of the edges and shapes needs to be correspondingly flexible. These wandering, apparently tentative shapes are often very rich and inventive. You can see this particularly well by turning this reproduction upside down.

31

Fig. 27

Fig. 27 is an enlarged photograph of the pattern on a stone, and it shows how the combined delicacy and strength of the 'drawing' in natural objects can result in a deeply satisfying quality.

The kind of shape that we are dealing with then — whether active, restful, firm or vague — has a definite bearing on the kind of composition we arrive at. And according to the way we use tone, these shapes can be either separated into a pattern or gathered together into larger masses which contrast with one another.

In differing proportions, of course, nearly every picture contains both these functions of tone. A Florentine painting of the fifteenth century, such as the Uccello in fig. 20, will be more likely to use fairly evenly scattered tonal changes, whereas a painter like Caravaggio or Rembrandt deals almost entirely with large, dramatic tonal groupings (fig. 30).

The Uccello that we have been discussing (fig. 20) uses a certain amount of all-over pattern made up of tonal shapes. Look, for instance, at the vigour of the scattered dark and light pattern of horses' legs, broken lances and bits of armour against the light ground (fig. 23). But there is also a good deal of tonal massing. The pale horses carry on the light tone of the foreground, while behind them the middle ground of the picture forms a predominantly darker mass in which there are quite big areas where the colours are very similar in tone.

A common reason for the failure of many pictures by inexperienced painters is a lack of purpose in their tonal structure. This can happen even in such a comparatively simple statement as a small portrait study. A 'jumpiness' of tone — so that, for instance,

32

planes on the head and on the clothes fail to relate properly to their surroundings and stay in their place — will inevitably lead to a lack of unity.

The painter who is sensitive to tonal relationships and pattern will compose his areas of tone so that they fall into groups, each of which contains closely-related values. This may be a matter of very small adjustments, deriving from very exact observation.

He will be aware of the bigger groupings of tone. For instance, in a portrait there may well be one group or scale of tones that belongs to the lighter parts of the flesh, while others relate to the darker shadowed parts, and to the darker and lighter parts of the clothing. He will make sure that the changes in tone which go on in each of these areas are closely related.

A broad and serene effect, instead of a jumpy and restless one, may be produced simply by this kind of precision. Any painting by Titian will serve as a supreme example of the simple grandeur of form produced by the grouping of tones in this way.

I have already described on p. 29 how Titian's *Entombment* can be considered as being made up of just a few main areas of tone. The light body of Christ connects, tonally, with the similar areas of the arm and the drapery round the legs on the left, and with the standing figure on the right. This big, rhythmic, light shape is interrupted by the shadow on Christ's torso and head. Within these broad areas of light and shadow, all other tones are kept subsidiary and exactly in relation; nothing jumps out. The dark features and beard are part of the dark area, just as the pale shadows on the legs are part of the light area. It is a good thing, in your own painting, to try to relate small tones to large ones in this way.

All these matters are important, and inevitably come up in any analysis of composition. Another point about the Venetian painters' use of tone is worth mentioning. Titian and Tintoretto, among others, often simplified or reduced the contrast of tone in certain areas as a foil to other more complicated and active passages. Values within one dark or middle-toned area, for instance, can be brought even more closely together, so that they become almost the same. One whole area of tone can be run into another in this way, and parts of the picture can be connected.

This happens in a very dramatic way in the Rembrandt in fig. 30, where all the dark shadows created by the strong lighting

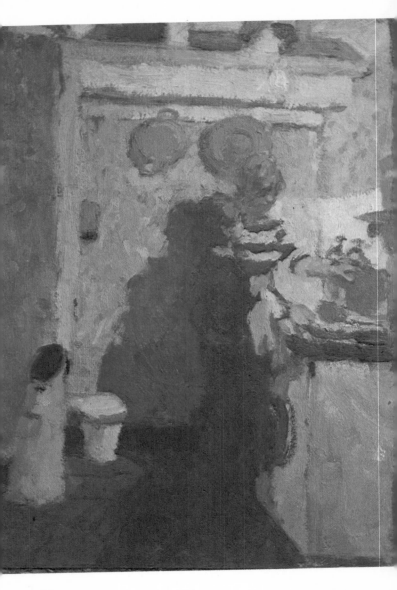

Fig. 28 *Washing-up* by Bernard Dunstan. (Collection Mrs W. Watson)

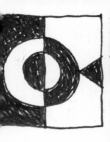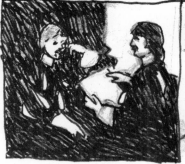

Fig. 29 Three different aspects of counterchange

flow together round brightly lit forms that emerge from them. But you can also see it happening in pictures like the Degas in fig. 79 and the Daumier in fig. 88.

A device that should be mentioned here is that which is known technically as counterchange. This refers to the contrast created by two (or more) silhouetted forms, one of which is light against dark while the other is dark against light. Fig. 29 shows an obvious decorative use of this principle, and a more subtle example from a painting by van Dyck. It is worth noticing how often this effect of counterchange occurs in nature, where, for instance, one often sees a dark branch or stem against the sky change to a light silhouette where it comes against dark trees. I will be referring further to the way that natural forms so often seem to 'design themselves' in a later chapter (p. 53).

Colour

All those aspects of design which depend on tone – on light and dark relationships – can also be carried out by colour. Counter-change, for instance, can be thought of as referring to one colour against another, instead of light against dark; a small shape of one colour within a bigger mass of another can draw our eyes as definitely as a small area of light does when surrounded by dark.

Can colour do anything else in the design of a picture which is peculiarly its own – which cannot be accomplished by the use of linear or tonal means? This brings us to the question of the 'spatial' action of colour. It is a well-known theory that colour can appear to advance or recede, and this can obviously be used to advantage in a composition which is arranged, so to speak, in depth; where shapes are considered as being disposed not merely *across* the picture surface, but into the depth of the picture space as well.

35

Fig. 30 Drawing after Rembrandt

Unfortunately the receding and advancing properties of colour have been very much simplified by some teachers, with the result that many students get the idea that any red will come forward, and any blue will go back. In fact it is not as simple as this, and is much more a matter of the intensity of the colour. If we take two blues, one of which is absolutely pure while the other has been mixed with other colours to reduce its intensity or 'blueness', and if their positions in the design confirm it, there is no doubt that the more intense colour will tend to appear in front of the less intense.

That phrase 'if their positions in the design confirm it' is very important. The diagram on this page (fig. 31) will show how completely two rectangles can be fixed in their respective positions in space merely by drawing a few lines, and how drastically the situation can be altered by changing these lines. Painting the

Fig. 31

rectangles different colours would make no difference whatever. Try this for yourself and see what you think.

Ruskin has pointed out that colour as such can only act as a 'sign' of nearness or distance, according to particular circumstances. Thus, as he says, 'purple in a violet or a hyacinth is a sign of nearness, because the closer you look at them the more purple you see. But purple in a mountain is a sign of distance, because a mountain close to you is not purple, but green or grey.'

So we can say, I think, that colour is less important than form or shape from the point of view of establishing objects in space, and indeed from the point of view of composition generally.

However, a few suggestions about the use of colour may not be out of place here; in a book on composition, as I pointed out at the beginning, practically everything will find its way in sooner or later.

Two of the most important things implied in the phrase 'a sense of colour' are, first, a sensitivity to distinctions of warm and cool (warm refers to colours which tend towards red, while cool colours tend towards blue), and secondly, a subtle use of the neutral hues. Perhaps the two are the same. It is only by being aware of slight changes in 'temperature' from cool to warm that we can use greys and neutral tones properly. To a colourist, there is hardly any plain grey. There are warm brownish or violet-greys, cool blue-greys, and so on. Even a completely neutral grey made up of pure black and white can look either warm or cool according to its neighbouring colours. Look up as you read at the objects around you, and try to decide which can be called warm in colour and which are cool. Can you find any that seem exactly neutral?

A picture can be designed in such a way that it is made up of areas, or bands, of warm colour, contrasted with others which are predominantly cool. Patches of warm colour 'spilt over' into the cool, or vice versa, will then have a comparatively powerful effect. In principle, this is exactly the same as the 'grouping' of tones into areas.

The use of two areas of exactly the same tone, but differing in colour, can be very telling when used as a foil for more obvious contrasts. Vuillard was a master of this particular subtlety, and there is a standing figure of a dancer by Degas in which her legs in shadow are identical in tone with the floorboards in light; they are only distinguishable because the floor is a warm brown while

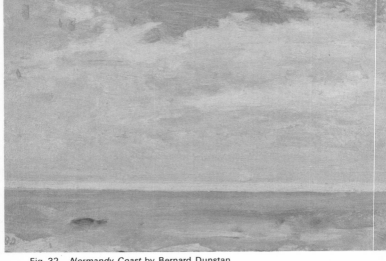

Fig. 32 *Normandy Coast* by Bernard Dunstan

the shadow on the legs is a purplish-grey.

The colour plates will illustrate these points. The cover picture, for instance, shows a picture built up in stripes (see p. 72), where the contrasts are carefully adjusted between the cool area (the wall on the right) and the warm ones (the figure in the brightly-lit room and the curtain).

The area of the doorway is actually almost exactly the same as that of the blank wall, but the intense orange strip at the left hand side has the effect of weighting the composition on that side, and this makes a different emphasis. Cover this orange strip, and see how much the whole composition is altered. The orange is hinted at in small patches of colour in other parts of the picture, and this helps to avoid its becoming too isolated.

The picture of the string quartet (fig. 48) illustrates the point about areas of the same tone but of different colour. The audience was dimly lit compared with the players, and in this dark area the slight colour changes are very important.

Rhythms and movement

So far, we have been looking at some of the elements that may be used in composing a picture. We have considered linear divisions, tonal pattern, and colour. In this section we have to come to grips with the way they are used, together or separately, to create rhythmic movements and tensions across the picture space.

Fig. 33 *Olga* by Bernard Dunstan

Balance and equilibrium in a picture may be achieved by using static, calm and equal elements. This is perfectly valid, and in a later chapter we will be discussing this among many other attitudes towards composition (page 66). However what we are going to investigate here, among other things, is another sort of balance, that achieved by the movement of lines and forces, creating a delicate equilibrium more like that of a cyclist — or indeed of any one who stands the whole top-heavy weight of his body on the soles of his feet.

A picture can be thought of in this way as something like a delicate machine or living organism. Every shape, line, tone or colour is a force, which pushes or pulls in one way or another, or acts as an anchor, so that the whole structure is held in balance.

Here are two examples of what I have called static design: a portrait and a beach scene. The head in the second one (fig. 33) is the single important unit, more or less isolated in the middle of the rectangle, while the beach (fig. 32) can be considered as a simple stripe.

Fig. 34

These are examples of the most static forms of design, and the simplest, because they use very few elements. It goes without saying that beautiful pictures can be made from such simple material if great importance is given to other elements, such as the colour.

But as soon as we begin to introduce shapes which get the design away from such regular and symmetrical structures, we are going to get a more active sense of movement and counter-movement in the design.

Fig. 35

Fig. 36

Fig. 34, for example, shows the simplest possible development from the portrait and the beach scene. You will see that the sea-shore now has more in the foreground and sky, the head has shoulders and arms, but the lines of each design are still symmetrical and calm. Yet even here we are beginning to set up some rhythms, if only in the dividing of the space into smaller areas.

As soon as the lines of these simple compositions begin to move away from the symmetrical, as in fig. 35, you can see how a very different form of structure begins to emerge; for now we are getting directions moving across and against one another.

I should, perhaps, mention at this point that all lines within the picture rectangle set up directions; they 'point' in one way or another. A strongly linear design, with a number of straight or vigorously curving lines as in fig. 16, or one in which the forms are delineated with sharp edges, as in fig. 76, will tend to create more definite directions than a structure which uses comparatively amorphous or smudgy areas of colour, or softly atmospheric colour changes, such as fig. 26.

Directions need not be created by continuous lines. In fact one of the most attractive ways in which a painter can enliven his picture surface is to set up rhythms by means of short, or interrupted, lines in different parts of the picture. These echo one another or pass an impulse along without actually being close to one another. They are connecting with one another in the same way as people throwing a ball to each other are.

These apparently disconnected lines in different points of the rectangle are, by the fact of being parallel or at right-angles to one another, or running in the same direction, making connections (fig. 36).

41

Fig. 37 *Outside Vicenza* by Bernard Dunstan

Fig. 38

You can find examples of these disconnected, yet linking, directions in practically every painting which has any complexity of design and which gets away from a straight symmetrical arrangement. Look, for instance, at a straightforward landscape like this one (fig. 37). Connections of this kind have been made, some conscious and some unconscious, all over the surface. See if you can pick some of them out.

Placing two important lines or directions so that they would meet at a right-angle if extended (fig. 38) is one of the oldest and most universally-used ways of strengthening the design of a picture; it has the effect of locking it together, one might say.

You will very often find this device used by Degas, who was a

Fig. 39 Drawing after *At the Milliner's* by Degas

master of logical and deliberate composition; a master, too, of the use of diagonal movements and thrusts, which is implicit in this type of design.

In *At the Milliner's* (fig. 39) two separate right-angled series of directions can be seen. I have emphasized some of them in this rough drawing. Reading from the left, both are initiated by the forearms of the milliner, holding the two hats; the upper one points through the hats and is crossed at right-angles by the scarf that the customer ties under her chin. This, in its turn, is picked up by the slope of her skirt and the top of the chair.

The second direction is echoed by the line of the wall behind the figures, and is crossed at right-angles by the wrist and hand of the customer.

On these pages are some more examples of the use of the internal right-angle, as it might be called. I have had to emphasize these directions in my rough drawings to give them more prom-

Fig. 40
Drawing after de Hooch

Fig. 41
Drawing after Turner

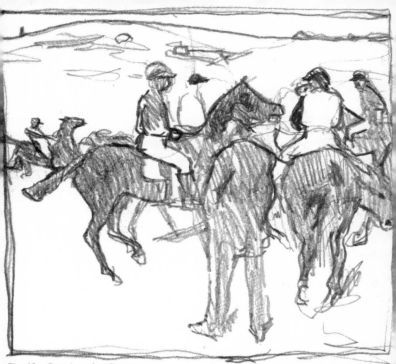

Fig. 42 Drawing after Degas

inence. In the pictures themselves they are a good deal more subtle and would hardly be noticed at first.

There are two rather similar de Hoochs in the National Gallery, London, but I only have space for one here (fig. 40). They are marvellously controlled designs, built up on a horizontal-vertical framework, with the diagonal and right-angled directions giving the composition just the right amount of movement away from regularity. These directions are extremely delicately balanced, never exactly at right-angles, but at sufficiently close approximations to give a degree of connection and stability.

The drawing after a picture by Turner shows very clearly the use of big right-angled movements (fig. 41).

Here is a typical Degas racecourse composition (fig. 42). It is full of linking and contrasting angular directions — mostly quite short — and even in a rough drawing I think you should be able to find quite a few. The divisions of space are also extremely carefully considered. Now that you have read this section, try making your own analysis of this design.

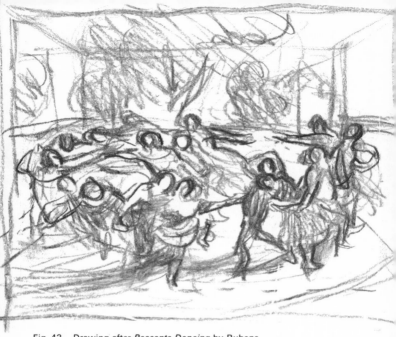

Fig. 43 Drawing after *Peasants Dancing* by Rubens

Curved movements

The movements we have looked at have been, on the whole, straight ones. As soon as we start using curving movements, we are beginning to move towards the type of design in which directions weave in and out of the picture space, instead of remaining on the flat surface. The difference is between two-dimensional movements on a flat surface, and three-dimensional ones within a box-like or stage-like space. A Rubens composition, for instance, can often be thought of as happening within such a stage (fig. 43).

Painters such as Tintoretto are said to have made small wax models of the figures in their pictures which they then arranged and lit with candles. This often-repeated story may well have been the case to some extent, but should not be taken too literally. Someone who knew his business as thoroughly as did these Baroque designers would hardly need to go the trouble of setting up model figures every time they worked out a composition.

Rubens's *War and Peace* is a fine example of this type of baroque, swirling composition (fig. 44), although the space

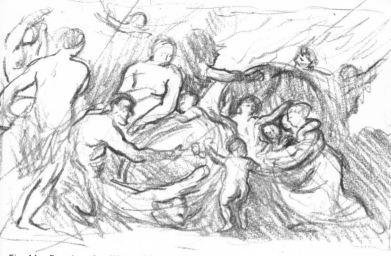

Fig. 44 Drawing after *War and Peace* by Rubens

Fig. 45

occupied by the figures is actually quite a shallow one compared with that of the *Peasants Dancing*. Instead of the one great circular movement, seen sideways on, which sweeps round the *Peasants Dancing*, Rubens uses several, rotating against one another almost like gear-wheels. You can see, I hope, from this drawing (fig. 45) how the rotating rhythms swirl in the middle of a great diagonal sweep which reaches to the very corners of the canvas.

Rubens, one of the greatest designers in the history of art, was able to breathe an immense and life-giving energy into any composition. We are not likely ever to try to make such complex structures; but by looking at them and trying to analyze them we can learn a lot about design, energy and movement.

Fig. 46 Drawing after Constable

The eye will tend to follow certain directions more readily than others. The simplest example of this is our tendency to 'read' a picture from left to right, in the same way that you are reading this page.

Prove this for yourself. Draw a rectangle and then divide it with a diagonal line, running from high up on the left side to low down on the right. It is natural to think of this line as running down from left to right, rather than as sloping up from right to left. This tendency may, of course, be used in a picture either to intensify a movement, or to counter it.

Again, a figure, or something which is moving or can move, which faces in one direction, will naturally lead the eye in that way. The more intense the movement — for instance, a gesture like a violently outflung arm — the stronger our reaction. Our response to any convincing and powerful human image is unconsciously to imagine ourselves copying the action. (This is an argument for the importance of figure painting; for no other form of art brings out this deep and instinctive reaction in us.) To get the same kind of response in abstract terms it is necessary to use a symbol such as an arrow shape, as seen in maps showing military movements.

Constable's *Cornfield* (fig. 46) is an example of both these kinds of reinforced movement. The big silhouettes of trees and field all slope down towards the right-hand side; but this inclination is vehemently countered by the curving sweep of the path,

from the bottom of the picture upwards and left into the cornfield. This movement is pointed out to us, so to speak, by the dog and the flock moving in this direction.

Repetition

One more aspect of design remains to be discussed in this chapter, in which we are examining some of the elements and devices which are important in the composition of a picture.

Repetition is so fundamental a part of almost every form of design that it is rather difficult to know where to make a start. Rhythm, whether in the musical or pictorial sense, obviously depends on repeating a shape or a direction, and the enjoyment of this is doubtless related to such a fundamental part of ourselves as our heartbeat or pulse. The repetition of an element in a picture can help to give a quality of unity, which enables the whole of a complex design to 'hang together'.

Repetition is not the same as repetitiveness, and so the echoing of one shape by another, or one rhythmic movement by another, need not produce any sense of monotony. As we saw in the earlier part of this chapter (page 16), a series of divisions across the picture surface can be sufficiently varied in its placing to give us a satisfactory sense of variety, combined with the unity created by their repetition. Our eyes are always pleased by a repeated form or group of forms which is a bit different each time, such as the irregular arches in an old bridge. This can be compared, in musical terms, to the phrases repeated higher or lower in the scale, or inverted, in a tune.

The vertical divisions in the Seurat in fig. 16, or the shapes of the arches in the Duccio in fig. 84, are good examples of the kind of direct repetition which is almost the pictorial equivalent to music.

Shapes, or groups of shapes, may be echoed or 'rhymed' in different parts of the picture in so subtle a fashion that at first one can be unaware of any connection. In a landscape, for instance, a small form can imitate a large and important counterpart; objects in the foreground can be linked in this way to others in the distance. Ruskin comments that this kind of repetition gives a sense of calmness and repose, and he makes a masterly analysis of a painting by Turner in which he finds a surprising number of

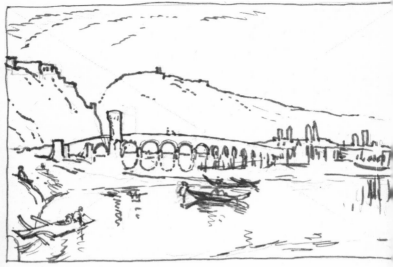

Fig. 47 Drawing after *Ehrenbreitstein* by Turner

links, or echoes, of this kind. He has done it so well that it would be superfluous to try to do it differently, so I have done a drawing of the picture (fig. 47) and have summarized Ruskin's conclusions.

Turner was very fond of this device of 'rhyming' and used it with the greatest virtuosity and expressiveness.

Ruskin comments on the fondness that Turner had for the reduplication of colours as well as of shapes; but in this rough sketch we can, of course, only show a few of the more obvious instances of shape-echoing.

The tower at one side of the bridge is the leading feature, or focus, of the design. It is repeated by a smaller, lower tower on the left, thus making a pair. This pair is then repeated all over the picture: the spires of the town on the right are all arranged in couples; the large boat has its partner behind it; and that one in its turn is divided into two. Each of these two smaller boats has two figures in it, and so on. Even the great mass of the cliff with the castle on it has almost its facsimile in the bank on which the girl is sitting.

There are some other points about this picture by Turner which Ruskin has commented on, and which may help to clarify some of

Fig. 48 *Quartet in B flat, K. 458* by Bernard Dunstan (Collection F. Kobler)

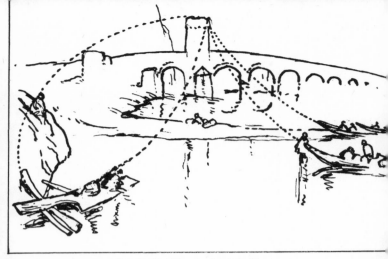

Fig. 49 Drawing after detail of *Ehrenbreitstein* by Turner

the points made in this chapter. A drawing of a part of the com-
position (fig. 49) will help here.

The left-hand side of the design, when isolated and enlarged,
shows even more clearly that a subtle system of related and
'rhyming' curves operates throughout the picture. The bridge
itself makes a long, slight curve, which is echoed in reverse by the
similar shapes of the boats. From the old rudder and the two
pieces of timber in the left foreground two long curving directions
are initiated, which both reach, eventually, the focus point of the
top of the tower; and the other boats to the right also point
towards it, as can be seen from the dotted lines.

Notice, too, how the prominent points in the hill above the
bridge, if joined together, make a sweeping and steady curve.

Finally, a good example of the use of a repeating series of
almost similar shapes can be found in the arches of the bridge.
There is no monotony about this long line of arches, because of
the slight but important variations in size and form that one
discerns as one's eye passes along the line.

Other examples of the ingenious use of repetition may be found
in many pictures and drawings by Turner. One, for example,
shows a very square castle on a sea-coast. To avoid the feeling
that the castle forms too dominant a square block in the design,
Turner scatters in the foreground a number of packing-cases —
part of the cargo of some ship — which echo the cubical shape on
a small scale and at differing angles. In another drawing, of

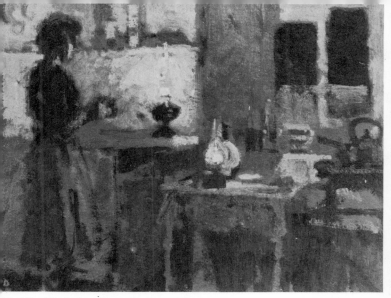

Fig. 50 *The Cottage Kitchen* by Bernard Dunstan

Richmond Bridge, the arches of the bridge are neatly 'rhymed' by the rotund shapes of open sunshades.

These, then, are some of the formal devices that the painter may use in the design of a picture. I must stress again that there's bound to be a certain artificiality about any attempt to analyze them in this way. On the whole, a painter does not consciously decide before he begins to do this and that; decisions are more likely to come out of the subject, his responses to it, and the way that other things are happening on his canvas. I am sure that pictures design themselves far more than we think; compositions happen all around us, and where a knowledge of these aspects of design can help is that it enables us to see and catch hold of possibilities that we might otherwise have been blind to.

There is a sort of natural order about the way things happen. I mentioned on p. 35 how often counterchange happens in nature – light coming against dark, changing to dark against light – and as soon as one becomes aware of a fact like this, it is remarkable how one begins to see it everwhere.

Here is a small picture which did not need to be consciously worked out – it was simply a question of seizing on what was there, though no doubt all sorts of partly-subconscious decisions were made during the painting (fig. 50).

Composition and observation

A painter can either start with a subject, and let his composition develop out of what he finds in it; or he can begin with a formal idea which dominates the subject.

This amounts to saying either 'I like this sort of landscape, let's see how it will work out on a canvas', or 'I want to do a picture with such-and-such a relation of shapes'. Needless to say, this is a violent over-simplification of what actually goes on; but it will do, I hope, as a starting point.

To begin with the formal idea, rather than with the subject, is not really like putting the cart before the horse, for there can be no doubt that a large number of very good pictures have arisen from an interest in making formal structures. But the former attitude, in which the subject-matter generates a form suitable for its expression, is the one that I am concerned with in this section. It is also, I believe, the one which has most to do with the business of painting from nature or from drawings, in a figurative idiom.

I would define a subject here as something which is exterior to the painter and his picture, and which can be referred to (either looked at, remembered or experienced) and compared with its image on the picture. It also implies an idea which is more than merely a formal, pictorial one.

I'm well aware that this is a difficult definition to make; the formal idea could well be considered as the subject. A good abstract picture, too, may well refer to concepts outside itself, such as gravity, weight, balance or tension, for which it makes equivalents. However, I think it is reasonable to distinguish between a picture which is, so to speak, responsible only to itself, and which can be developed without reference to its subject, if any; and one in which the subject always retains a certain power and influence.

It is only when the subject has this importance that the design of the picture can really grow, without having to be chosen at the beginning. When a painter in an abstract idiom starts a new picture, or group of pictures, he is bound to consider formal questions first of all – Shall it be a square with divisions? Shall the colour be flat or gradated? Will the emphasis be central, or all over?

The painter of figurative pictures who is interested in his subject matter will probably have a far more empirical attitude, if he is not too restricted by ideas about what is 'right'.

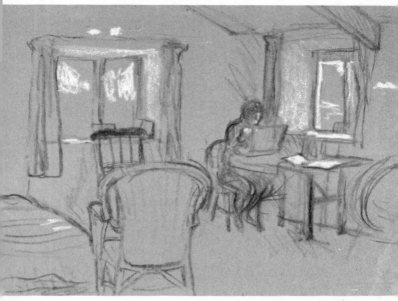

Fig. 51 A drawing of an interior in which everything has been included exactly as it happened to be. From this material many different compositions could evolve, see figs 52-54

Let me take some examples to show how the painter's absorption in his subject matter can dictate the form that his picture takes. First, let's imagine that the subject is an ordinary room with a figure in it – the sort of subject that we continually see around us (fig. 51).

This drawing will give an idea of the total appearance of the scene, the raw material from which we can take what we like. I've tried to make this drawing as complete, objective and even unselective as possible. I would have used a photograph here, but no lens will take in as broad a view as this without distortion.

Now when we make a picture out of a mass of raw material like this we are bound to select. In fact it was quite difficult to draw it without composing it, even unconsciously. However, selection does not merely mean leaving out everything that doesn't immediately seem necessary or desirable. I would recommend to any beginner that he should try, within reason, to put in everything in the particular scene that he chooses to paint. If you start leaving things out in the interests of simplicity – if, for example, a piece of furniture against the wall is left out – something has to go in in its place, and the result is likely to be much duller than the original set-up would have been if it had been observed

55

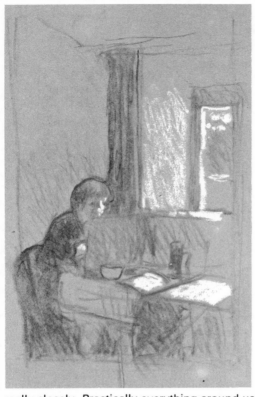

Fig. 52

really closely. Practically everything around us can yield interesting relationships of form, tone and colour, if only we look hard enough and with the right kind of interest.

Our problem of selection, then, can be narrowed down first to a consideration of the shape and size of the bit we want to paint.

It is certainly possible that the painter might start off by saying, in effect, 'I want to do a tall thin picture'. He might have a long canvas that he wanted to use. Or someone might have asked him to do a picture in that proportion, to fit into a certain space. However, I think a better reason for doing a long picture would simply be that his eye was caught by the way that the shape of the window related to the figure below it (fig. 52).

Here are some more equally valid compositions that have been found in that view of a room with a figure (figs 52–4). You will notice that in each of these drawings a certain amount of emphasis has been placed on a different feature. In fig. 52 it is the way the dark shapes connect up, in fig. 53 it is the division of the

56

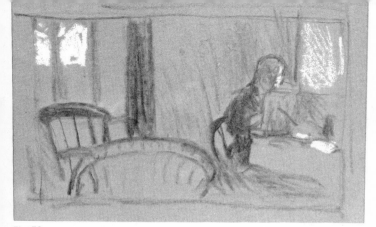

Fig. 53

long rectangle with the verticals of window and curtain, and in fig. 54 the rhythmic connection downwards from figure to chair-back. The fact that this has happened shows, I think, that it is not merely a matter of taking this little bit or that, as a photographer might look through his viewfinder. Each selection has been made because one feature or another, out of the host of possible ones, has been chosen as a theme. The idea, as well as the shape and proportion, is different in each of these three alternatives.

Fig. 54

Working from nature

A picture can be made from very little; and even that very little might, at first sight, seem unimportant to the majority of people. The painter needs to be on the alert all the time, to perceive in the apparently confused reality around him the connections, the linking rhythms, the hinted-at shapes and balances which may bring his design to life.

This is one of the eternally fascinating things about drawing and painting from nature. As one continues to work, to stare, compare, and make marks on the paper or canvas, one begins to see relationships which were invisible before, and which one knows very well would be quite unnoticeable to someone who merely glanced at the subject — even to someone who looked at it with love. There is all the difference in the world between looking at a thing and drawing it.

These connections and rhythms — the sort of thing that we were discussing on page 41 — can be hidden beneath the surface of the painting, so to speak, as they are in nature. They should certainly never be arbitrarily imposed on the subject, for they are everywhere, and only hard looking in the course of doing the picture will disclose them. Neither should they be made too obvious. A painting such as the Vermeer in fig. 70 or the Degas in fig. 73 goes on releasing its subtleties for as long as we look at it.

All this is, to me, a very good reason for doing figurative painting; it is why this activity seems so much richer and more inexhaustible than abstract painting could ever be. There are more 'layers' to it.

The subject-matter could be called the top layer, and the picture can be appreciated — as children will look at it — with this predominant in the mind. At the same time the abstract or formal qualities can be enjoyed, just as much as in a purely abstract picture. And in yet another way, the two can't be separated; one is continually overlapping the other, and influencing it.

I am convinced that in some way the picture gains greatly from the fact that the painter is thus working on different levels at the same time. He is thinking of his subject, its individuality, and the qualities in it that he wants to stress; he is also thinking about the formal qualities, both in the picture and in the subject, which are being gradually unfolded and developed in the processes of looking and painting.

The continuous interchange and feed-back between these two levels — the way that, for instance, a formal discovery can give one a slightly different view of something very characteristic about the subject — is what gives good figurative painting its particular tension and inventiveness, even oddity, which is seldom achieved in abstract art — for me, at any rate.

This is very far from the attitude, still sometimes expressed, that the painter is only 'copying photographically', because his eye is fixed on the subject.

This Degas pastel of a girl getting into a bath (fig. 55), for instance, can be looked at as a superb abstract, but it works on other levels besides just that one.

Fig. 55 *Le Bain* by Degas

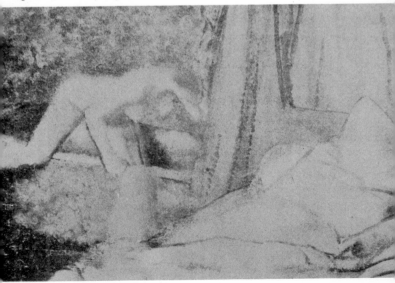

Respect for the subject

While we are dealing with the question of the painter's response to his subject matter (and to me, this is the most important of all the factors which relate to composition) I'd like to add a word on what I can only describe as respect for what we paint.

I am opposed to the idea that the subject of a picture is a mere starting point — a source of forms and colours, which may then be used, altered and varied quite arbitrarily at the will, or whim, of the painter. This is an idea commonly held, and widely taught; and to my mind it is responsible for as much, or more feeble painting as the old recipe of exactly copying the subject.

Immense numbers of essentially purposeless, semi-abstract pictures are turned out every year in the schools, pictures in which there is no real interest or involvement in the student's original subject. Because it has been impressed on the student that he mustn't copy, whatever he does, his natural interest in what he sees around him is diminished; he feels that in order to be a real artist he has to 'make something out of it'.

An artist of great sensitivity and maturity can depart radically from his subject, of course. The obvious and most extreme example is Picasso, who can pull his subject to pieces, transform, and rebuild it in the most violent way. The result is almost always justified because of his deep involvement and attachment to what he paints.

But I am sure that for most painters, and certainly for all beginners, the genuine discoveries are made from an unpretentious and humble attitude towards what they see. This should never mean that the resulting picture is undesigned or merely literal — which is what we mean when we use the word illustrative. The picture surface must come in for its measure of respect, too.

As an example of what I mean by respect, for both the subject and the picture surface, look at Turner's *Calais Pier* (fig. 77). Now Turner had no hesitation at all in altering the facts; and in any case a picture like this was done largely from memory — although a remarkably well-stocked and retentive one.

Starting from his powerful memory-record of the mood and movement of the scene, he develops a complex formal design, but never alters arbitrarily for abstract or decorative effect. Everything that he does, in fact, intensifies the tremendous energy of the picture, and increases the sense of reality.

How a composition can grow

Fig. 56 Studies by Bernard Dunstan made at a concert

would like to illustrate this with a few examples of the way that the composition of a picture can develop. I have to use my own pictures, because they are the only ones that I can have a full knowledge about from this point of view.

They are in fact paintings that were done from drawings and not directly from the subject; but the principle remains the same. Discoveries can be made either at the drawing stage, when the artist has his subject in front of him, or later on when the studies are being translated into the final picture.

The first picture was done from drawings made at a concert. I reproduce two of these studies here, fig. 56, so that you can see the kind of material from which a picture of this sort can be made.

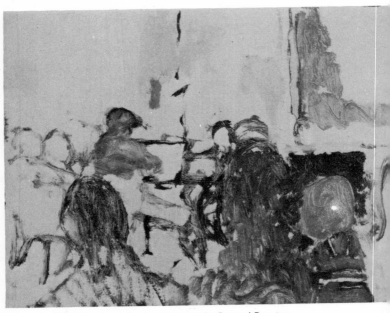

Fig. 57 First stage of concert painting by Bernard Dunstan

They are informative notes, rather than finished drawings, and are covered with written memoranda about tones and colours. At this stage of drawing, two things are going on at the same time: collecting as much visual information as possible, and beginning to work out possible ways of using this material – in other words, ways of composing the picture. The top drawing illustrates the first of these and the bottom one illustrates the second.

At this stage, the picture could turn out either as a long-shaped panel in which the heads of the audience would play a very important role and the quartet would be relatively small; or differently shaped, with the quartet made much more important in the picture space.

In the first stage of the painting (fig. 57), the main shapes have been put down and an indication of the divisions of the background has been made. This has led to the discovery that a square is made, at the division between the lighter and the darker part of the wall, which might turn out to be useful. The stripes on the dress in the foreground (right-hand side) seem interesting, and so are indicated; the tone generally is just beginning to develop.

Fig. 58 shows a later stage. Some big areas of tone have been

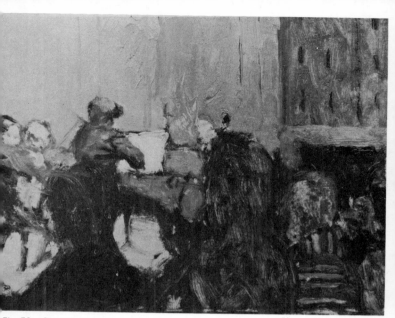

Fig. 58 Second stage

worked out more, and this gives some idea of the important shapes. There doesn't seem to be enough difference between the tone of the audience in the foreground and the quartet, and some of the shapes are a bit too much alike in area and character. A final stage is shown in colour in fig. 48. Various important shapes have been clarified – for instance the gaps between the musicians' feet and the heads of the audience – and further adjustments have been made to the tonality and emphasis of the whole.

All these changes are comparatively small, but I mention them to emphasize the importance of this aspect of composition. It is a great mistake to think of the design of a picture as something that is decided at the beginning once and for all. It is rather something that grows and develops all the time that the picture is on the easel, and apparently small adjustments can make all the difference between a composition that works and one that doesn't.

In this particular picture, the main shape of the design was not altered. Once the first decision was taken, the process of composition related more to the way that small things were adjusted.

The same material was used in a composition of a different

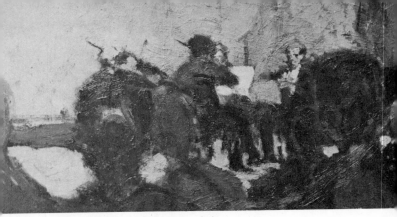

Fig. 59 Another study for concert painting

shape (fig. 59). The long format was considered as an alternative at the time the drawings were made, and I made a small note of the possibility.

These are examples of working from drawings; the elements of the picture were not altered from the original visual impression. The composition consisted of finding a satisfactory format and then a continuous process of adjustment of comparatively small, but very important, relationships.

You will probably find that you use a similar approach to composition when painting something in front of you. Let me stress again that once you have chosen your motif, you are more likely to produce something interesting by accepting what is there, and trying to find out as much as you can about it.

The design of a portrait, if more than the head and shoulders are to be included, is a matter of moving the sitter about and trying different attitudes until the lines of arms and so on fall comfortably into the format. Although this is a comparatively elementary process, it is none the less composition, and can be very subtle.

If you have tried to paint portraits, you will know how often the sitter takes up a much more expressive and naturally 'composed' attitude as soon as it is time for a rest. Always be prepared to alter your ideas and seize on something which happens naturally in this way. The way things happen and arrange themselves naturally nearly always has an ease and rightness far greater than conscious arrangement can produce. The casual clutter of a table after a meal is a good example of this. A very important part of the art of composing pictures is to be alert to all such chance happenings and to take full advantage of them.

My last example relates much more closely to what most people

Fig. 60 A drawing made for the painting in Fig. 66

think of as composition. The picture is shown in colour in fig. 66 and it was entirely 'put together' from drawings like the ones shown here (figs 60, 61). This process was naturally more conscious and deliberate than that used in either painting direct from one drawing (figs 56-58) or arranging something to be painted from nature. There is far more possibility of exercising choice — any shape and any colour can be altered. The distinction, in fact, is between a subject which has at some time been seen as a whole, in reality (as examples, see figs 26, 50, 87), and a subject which is 'invented' on the basis of separate observations (for example, figs 20, 62, 76).

Fig. 61 Another drawing for Fig. 66

Some different kinds of composition

In an earlier chapter (p. 16) I have tried to isolate and examine separately some of the aspects of picture-making which can be important from the point of view of composition — although, as I said at the beginning of this book, to write about composition means bringing in practically everything else about painting.

It was necessary to separate these aspects, in the interests of clarity; but the sooner we get back to the whole picture, and examine it in relation to the demands of its subject-matter, the better.

To talk about tonal balance or linear proportion, as if one were dealing with abstract principles or rules that could be applied to any subject, can be dangerous, as I've pointed out already. It tends to reduce the whole thing to a formal exercise. So in this section I want to look at a number of actual paintings, of all kinds and periods, by modern painters as well as by the masters, to try and see how and why their particular quality of composition has been arrived at. They represent different, but equally valid, attitudes to painting. I'm not going to try to classify the various kinds of composition represented by them; they shade off so imperceptibly into each other that this would be a pointless exercise. However, I have thought it reasonable to group pictures together that have a certain relationship with one another. Some pictures are included which can't be classified at all; they happen to illustrate one or other aspect of design.

As you go through this chapter, try to relate these different sorts of composition to your own work. There will be many that seem to have no relationship; but in many others I hope that some aspect at least may have a bearing on something that you have tried to do, or may open your eyes to something in your own pictures.

We will start with a group of pictures which represent calm and relatively static modes of design.

The simplest and most obvious form for a picture is that in which the main subject is placed in the middle. Many people have an idea that this is always to be avoided; but a walk round any gallery will show you that a centralized design is constantly used by the greatest painters, and is, in fact, inescapable for many subjects.

The most obvious example is a portrait in which the head is the

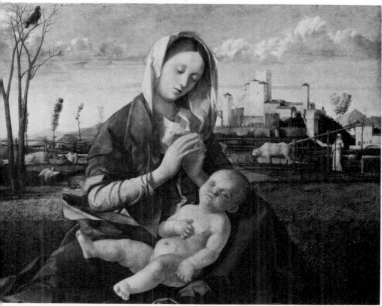

Fig. 62 *Madonna of the Meadows* by Giovanni Bellini. National Gallery, London

main point of interest. It would clearly be absurd always to place
the head consciously off-centre; it may well belong quite nat-
urally on the central vertical axis of the canvas (fig. 33).

Other subjects of a hieratic or religious nature seem to fall
naturally into a centralized scheme. Where one person is quite
obviously the most important in the picture, as, for instance, a
Madonna and Child with surrounding saints, it is natural to make
this figure central, particularly if there is no occasion for any strong
movement across the canvas. A beautiful example is Bellini's
Madonna of the Meadows (fig. 62) where the Madonna and
Child are placed absolutely centrally, forming a triangle. This
symmetrical scheme forms a basis for a series of subtle variations.
Within the central triangle one can find a number of diagonal
movements: the mother's head, the axis of the child's body and
head, and the left leg. These are countered and stabilized by very
subtle vertical and horizontal accents: the vertical line of the
fold running down the Madonna's head-dress, and the horizontal
axis of the child's right leg.

These movements are echoed in the beautiful landscape back-
ground, with its verticals and discreet diagonals. Notice how
particularly subtle is the placing of the towers on the right. Other
refinements are the way that the large triangular shape of the

67

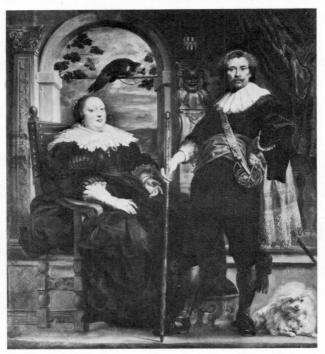

Fig. 63 *Portrait of a Man and a Woman* by Jordaens. National Gallery, London

group is echoed by smaller triangles — the hill at the right, the Madonna's shoulder where it meets the head-dress — and the gentle inclinations of the trees which echo the tilt of her head.

Here is another example of a picture designed round a central axis (fig. 63), this time with two main subjects. A double portrait is almost bound to resolve itself into two rather equal halves, unless one figure is made definitely subordinate to the other. Obviously Jordaens didn't want to do that here, even if his formidable sitters would have allowed it, and he has emphasized their equality by placing the man's hand in the exact centre of the rectangle, while the staff marks, with the side of the arch, the vertical axis.

Having made this absolutely stark formal statement, Jordaens is then able to embroider his forms with all sorts of slightly over-weight elaboration. Essentially, though, the character of the design springs from the character of the sitters and the way they must have had of facing the world as a partnership.

So the idea, often put forward, that one shouldn't put any-thing exactly in the centre of the picture, in case it should 'fall into

Fig. 64 Drawing after
The Ambassadors by Holbein

two halves', can be seen to be quite fallacious; all sorts of good pictures are designed round a centre. Holbein's *Ambassadors,* for instance, has its two figures arranged on either side of a square picture shape (fig. 64). The middle is occupied by a mass of still-life, and two short vertical edges carry the central vertical axis unmistakably and neatly down through the picture.

The still-life painting by Charles Mahoney in fig. 65 plays cleverly with the idea of centrality. The actual middle of the canvas (a double square) is shown by the left-hand one of the two central plants. The extremely equidistant placing would probably have been avoided like the plague by most beginners, but the fact is that a simple row of objects like this can be a very telling arrangement. Look out for such rows on your own table top, or try to arrange some.

A line of objects like these plants runs across the picture sur-face parallel to the plane of the canvas. This is the case, too, with a frieze-like design.

Fig. 65 *Auriculae* by Charles Mahoney

Fig. 66 *Dressmaking, Wendy and Louise* by Bernard Dunstan. (Collection Mr Austin)

Here is a Poussin which uses the frieze-like form (fig. 67); the figures are strung across the picture and occupy a very shallow space.

One of the charms of this sort of design is the way that a chain of connecting directions can be linked up. Look at the pattern that is made by the arms in this picture (fig. 68).

I have purposely isolated one such 'chain' here, because it is of such beauty; but you will be able to find plenty of other carefully-arranged connections.

Look at people around you, in an office or a kitchen for instance; can you isolate some frieze-like incidents, such as people passing things to each other?

70

Fig. 67 *A Bacchanalian Revel* by Poussin. National Gallery, London

Fig. 68

Fig. 69 *The Convalescent* by Gilbert Spencer. Photo Royal Academy, London

Just as many fine pictures are built up on a very simple central-ized arrangement, so there are many which, essentially, are made out of stripes. We have only to think of the number of landscapes in which horizontal lines of beach or field, distance, and skyline, make a series of delicately-contrasted parallel stripes.

But here is something a little different, a window picture by Gilbert Spencer called *The Convalescent* (fig. 69). The two big stripes of the window frame space out across the picture and enclose the figures. The upper line is unbroken and the lower is cut only by the boy's arm. Here Spencer has seized on something we have all seen at one time or another — a view through the slit of an open window, a little scene enacted in this confined space before the actors retreat into the darkness of the room — and it has determined the kind of composition he has made.

Spencer's method of painting goes back to the simplicity and directness of the early Italians. Flat or simply-modelled areas are disposed across the picture space, with a strong emphasis on linear construction. The characteristic shape and personality of each object in the picture is lovingly observed — the white iron bed-heads against the flowing shapes of sheet and windows, the irregular shape of the sheet seen between the two arms.

Look around you and see if there are any possibilities of making 'stripe' compositions in your daily environment. The top of a

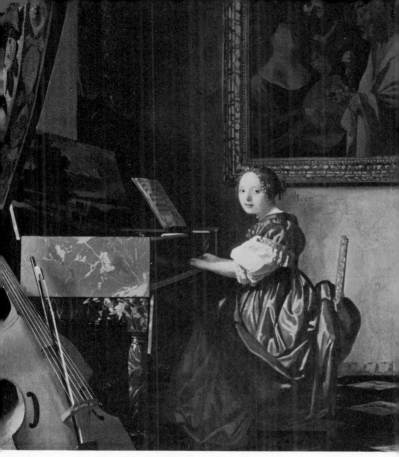

Fig. 70 *Lady at the Virginals* by Vermeer. National Gallery, London

table, with people sitting behind it, might form a starting point.

This brings us rather conveniently to an important type of composition, which could be called the geometrical interior. This is seen in its highest degree of sophistication in paintings on a small scale by such masters as Vermeer, de Hooch and Vuillard.

The interior, with its straight lines and divisions of space, obviously lends itself to a formal and geometrical basis for composition. Vermeer's pictures are the epitome of this ordered and mathematical art, in which the figures are held in perfect equilibrium within the complex framework of walls, windows and furniture.

73

In the *Young Lady at the Virginals* (fig. 70), reproduced on the previous page, the stable rectilinear framework relates to the Golden Section proportion (page 19). Examples of this are the placing of the girl's head, the upright of the picture frame, and the bottom edge of the case of the instrument she sits at. There are many other less obvious examples. The design is still further stabilized by the construction of squares within the picture area. One of these can be found defined by the bottom line of the virginals and its hanging-down lid; this square encloses the body of the viol. Another is established by the top of the virginals' case and the vertical line of the picture frame.

Against this basic rectilinear scaffolding, Vermeer finds a series of diagonals. Both the strings of the viol and the curtain make angular slices against the left hand side of the picture. To prevent this from being too regular, another less extreme diagonal is formed by the bow; and this is continued by the lid of the instrument. The music repeats the slope of the viol, and this again is picked up by the girl's skirt – a subtle echo, this, because the skirt is not straight; but it is definite enough to continue the line of the music.

Finally, from all the complexities of this wonderful formal structure, let me pick out one example of the internal right-angle; the rather square shape of the girl's sleeve is tilted so as to make an exact right-angle with the strings of the viol.

Many other correspondances could be found, but an analysis of this kind can become exhausting. I hope I've pointed out enough to show how conscious and finely wrought a design of this kind can be. But it would be a great mistake, in my opinion, to consider a painting like this too exclusively from the point of view of geometry; and the same would apply to any other picture in this book.

Unfortunately, it is much easier to talk about geometry, and to make neat analyses, than about other, and even more basic, aspects of making a picture. It would be quite easy to visualize a painting as completely organized as the Vermeer which is dead and academic. A good picture must have more than geometry or an impeccable construction. As well as the formal aspects – such as drawing, colour relationship, the grasp of form and space – there are the less definable human qualities, depending on what the artist feels about his subject matter and how deeply he is in-

Fig. 71 *Landscape with Apollo* by Claude Lorraine. National Galleries of Scotland, Edinburgh

volved with it. All these aspects are so closely interwoven that it is impossible to separate them. The constructive or geometrical aspect is also tied up inseparably with them, in spite of the way we tend to consider it apart.

This landscape by Claude Lorraine is a classic example of what could be called the 'stage-set' form of design (fig. 71). It can be thought of as made of parallel planes going back from foreground to distance, in the way that scenery is placed on a stage.

The figure is on the furthest forward of these planes. The great mass of trees on the left, and the smaller balancing one to the right, are on a parallel plane in the middle distance, while other planes define the recession into the extreme distance.

There is something extremely stable and peaceful about a design worked out in this way. Other pictures by Claude, and by other painters who have imitated him, show even more clearly the classical placing of a mass on either side, leaving a central gap through which the eye can move smoothly, plane by plane, towards a beautiful distance.

Fig. 72 *York Festival* by Richard Eurich

This painting by Richard Eurich takes the 'stage-set' arrangement a step further (fig. 72). It is made up of two foreground 'wings' and a central part of the composition which leads into the distance. The symmetrical divisions are made in such a way that the picture becomes a triptych, a picture divided into three parts. The two lines of smoke rising into the sky reinforce these vertical divisions. The two side masses each have their own 'way in' towards the distance, which prevent them from blocking off the sides of the design too much.

Large masses at the sides of a picture can lead you towards something important further back in the picture space, and they can act as stops to prevent your eye from moving outwards. When they have the latter function, they are traditionally known as 'repoussoirs'.

The bed in the foreground of the Degas pastel called *The Morning Bath* (fig. 73) fulfils the same function of leading into the middle area of the design. Here, however, everything is asymmetrical and diagonal, full of tensions, and it makes the strongest possible contrast with the classical calm of the last two paintings. It is, in fact, a good example of the sort of design which depends on movements, thrusts, and counter-thrusts to achieve an equilibrium, in the way that I discussed on p. 39.

You can find in this picture many of the features that we were dealing with earlier. Many of the directions run parallel to others, or if continued would meet others at right-angles.

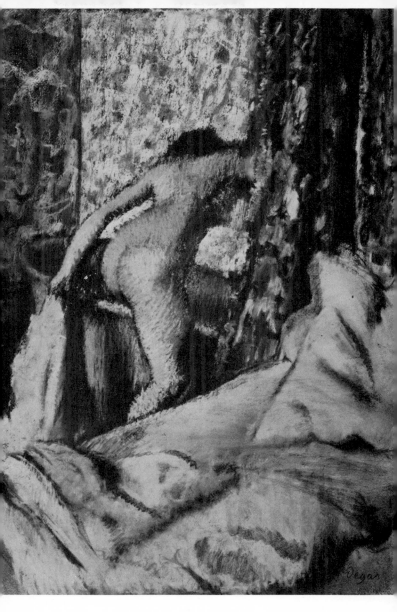

Fig. 73 *The Morning Bath* by Degas. Courtesy Art Institute of Chicago

Fig. 74

Some of these are roughly indicated in this drawing. You will notice that a tilted square is hinted at, right in the middle of the picture, and almost every diagonal has its 'rhyme' somewhere. Thus the girl's left arm is paralleled by a fold in the bedclothes; the axis of her thigh is at right-angles to the edge of the bed. Strong verticals run down the wall and continue in the shadow of the towel, and the front of the thigh, to help to stabilize these powerful movements.

Raphael's *Madonna of Loreto* (fig. 75) is another example of a powerfully-organized design depending on vigorous thrusting movements within a compact picture area. A design of this kind is often strongly asymmetrical, and the tensions which are set up work definitely within the shape of the picture, not implying any continuation beyond it. In the case of this Raphael, the enclosing area is rather square in character, and this in itself seems to imply a self-contained set of movements. This will be found also in other square and near-square pictures.

The directions in a picture like this are stronger than they are in a geometrical interior of the Dutch sort, like the Vermeer that we were looking at a few pages back (fig. 70). There, the oblique directions make a comparatively-static contrast to the horizontal-vertical scaffolding which holds them firmly in their place. Here there is no such framework to keep them in place, only their own equilibrium and balance. In fact the design, for all its greater dynamism, is just as secure and stable as a Vermeer.

The canvas is not square, but the line of the edge of the mattress at the bottom cuts a strip off and makes us feel that what is left is square. The Madonna's arm makes a powerful horizontal echo of this emphasis on the bottom edge of the picture, and almost every other movement is vigorously slanted.

Fig. 75 *Madonna of Loreto* by Raphael. National Gallery, London

Fig. 76 *Demolition Squad* by William Roberts

William Roberts, more than any other modern painter, is able to compose a picture of contemporary life with monumental grandeur. This kind of figure composition (fig. 76), with its massive rhythms, is descended from such Florentine masters as Masaccio and Signorelli. Like them, it uses a logical and orderly construction, and simple forms. Notice the use of repetition, and the way it grows naturally as a formal device out of what was happening in the actual scene. For instance, the men at the right warming their hands over a brazier, or the group at the left passing the bricks along from hand to hand, are engaged in actions which naturally create repeated shapes and movements.

There is a wavy shape which is repeated all through the picture — in the girders, the walls of the bombed buildings, and the body carried on the stretcher.

Behind all this ingenious repetition there is a larger structure: on either side of the design there is a vertical build-up of figures, their opposing diagonal movements running across the upright mass. These two sides frame a central area across which the action of the figures moves.

The colour plates

Perhaps this would be a suitable place to comment on the colour plates. I have already used the cover picture to illustrate some remarks on colour (p. 38). Another picture which was painted in very much the same way — partly from nature and partly from a drawing — is *Washing up* (fig. 28).

This painting developed directly from the first impression, which was of the way the figures were enveloped in a mass of shadow. This has the effect of connecting them together into one dark mass. Contrasting with this were the sharp, bright accents of colour provided by the blue circular pan, the red packet on the shelf and the yellow bucket. There is also quite a strong rectilinear framework, made up of the lines of wall, ceiling and floor, which 'contains' this large dark shape.

The picture of the concert (fig. 48) has also been described, and the only point I want to make here is to mention the tilted right-angled structure made by the arms, the bows, the music and the neck of the 'cello. This is carried down to a point between the shoulders of the people in the foreground. Again, this feature was discovered and developed in the course of painting.

Fig. 66, *Dressmaking, Wendy and Louise,* is an example of a 'made-up' picture. First, a number of drawings were made, and it was essential to have at least two models together at this stage (I would have preferred all three).

The actions of trying on a dress were allowed to dictate the design, within the rough preconceived idea I had in mind — that of having two figures together and the third linked with them, but pushed right over to the edge of the picture. I had already done a number of versions of this subject, using two figures, and I was interested to find out the possibilities of expanding it to three. A second version was begin at the same time, with the figures in a different setting.

A few studies were made of the whole design, like figs 60-61, but on the whole the composition was worked out on the canvas.

The small landscape by Diana Armfield (fig. 81) was also done partly on the spot and partly afterwards from a drawing. This is a good example of an apparently perfectly straight forward painting from nature which is actually made up of innumerable small adjustments of shape and colour. Notice, by the way, how closely related the colour is; it would have been very easy to exaggerate the contrasts, even very slightly.

Fig. 77 *Calais Pier* by Turner. National Gallery, London

Most seascapes are inevitably dominated by the line of the horizon. In Turner's *Calais Pier* (fig. 77) the horizon is comparatively obscured by dark storm cloud, and the steep perspective of the pier itself, as it swings inwards with a powerful thrust, becomes a dominating factor in the composition. This is an example of the use of movements going into the picture space, as well as across it.

This picture is dark, as well as being very large, and I am afraid you may not be able to see some of its many subtleties of design in a small reproduction. However, I will try to point out some of the more obvious ones. The dominating mood of the picture is stormy, with a tremendous wind blowing through it, and many of the shapes have a tattered wind-blown quality — the clouds, the flags, the wave-tops, and the figure on the pier all share this. Then the diagonals, which make up such an important part of the design, are infinitely varied. If you 'read' across the picture from left to right, the lines of the masts make a restless rhythm which has something of the quality of a musical phrase.

The figures in the boats and on the pier make gestures that link them: a reaching-out movement of the arm, particularly, which repeats a horizontal accent as a counter to the violent movement of the water below. The big diagonal of the pier itself is broken in

Fig. 78 Drawing after Turner

various places — by the wave breaking over it in the foreground, by the figures, and then by the light mast crossing it. Its main direction is echoed by the large dark sail on the horizon. This, in its turn, is echoed by a tiny, brightly-lit sail even further out; another example of Turner's fondness, already commented on, for making pairs.

Another typically Turnerian subtlety is the big curve of rope lying on the planks of the pier. This has at least two functions — it breaks into and contrasts with the otherwise rather insistent perspective lines of the planking, and it echoes the curving shapes of the waves in the foreground, and also, in a reversed way, the curve of the big light sail. Links are thrown, so to speak, from one part of the picture surface to another, using forms that echo each other's shapes while retaining their own individual character. The sail still has its particular curvature, altering according to whether the fabric is taut or loose, while the rope has exactly the right tensionless curve. This point is an important one, I think. Many modern painters, dealing with this problem, would make all the shapes 'work' in an abstract sense, without worrying about whether they still retained the character of the material. Turner, by stressing both aspects, achieves an extra level of expression.

Here is another example of a painting by Turner, which uses steeply-receding directions going into the picture space.

This note (fig. 78) was made in the gallery in front of the picture. One can learn a great deal about a picture by making quick drawings like this. It is always better, if possible, to draw directly from the picture, and to draw exactly as if one were drawing from nature. You can, of course, draw from reproductions, but you will then be more likely merely to copy. There is a subtle but important difference here. Even the quality of the colour and the

paint surface of the original in front of you makes a difference, I find, to the resulting drawing.

Make sure that the proportions of your study are the same as those of the original. It is surprisingly easy to overlook this, and to change, for instance, a long rectangle into a square one. This would, of course, radically alter the character of the composition. Often you can start in one part of the picture and draw outwards until you come to the edge, thus letting the outer shape of the picture develop gradually, instead of putting in the rectangle at the beginning and trying to fit the picture into it.

So get into the habit of taking a small sketch-book with you when you go to a gallery. A small drawing can be made standing up, if necessary. Concentrate on the shapes that you feel to be important, and indicate the tone as best you can. You'll learn a lot about composition in this way, particularly if you look on your drawings as analyses, rather than as copies.

Apart from this, you will be surprised at how much better you can remember a picture you have made a note of it in this way. The mere act of drawing something seems to help fix it in the mind. And, of course, you are looking at the picture for much longer than if you merely paused in front of it and then bought a postcard of it on your way out!

Degas's *Woman at her Toilet* (fig. 79) is a large pastel on paper. Like the other Degas, *The Morning Bath* (fig. 55), there is a big diagonal running from side to side of the rectangle, but in this case the other shapes are, so to speak, strung around this line. There are some very odd shapes resulting, many of them kept quite flat. If you turn the picture upside-down, you may be able to see them more readily.

This, by the way, is always a good way to see your picture afresh; you'll often find that unexpected rhythms, shapes or connections appear.

Look at the way that the profile of the big vase on the right is echoed by the edge of the white cloth on the table; the shape is repeated, so to speak, at right-angles. Repeated and tilted right-angles are also made by the arms. I've indicated some of the major connections in this little scribbled note (fig. 80).

But there is something else that I particularly want to point out about this beautiful pastel, something that I haven't yet talked about at all. This is the part that can be played by the

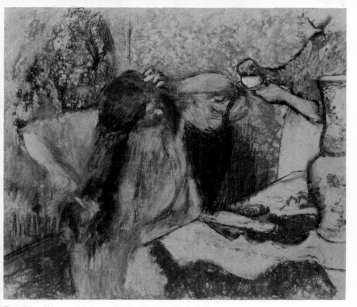

Fig. 79 *Woman at her toilet* by Degas. Tate Gallery, London

Fig. 80 Some of the repeated right-angles in the design

quality of the edges, the emphasis or lack of emphasis given to
them. A slight accent on a particular edge may bring out a
direction with remarkable force; a softening or 'losing' of an edge
can bring together two adjacent forms so that they almost become
one (fig. 25). Look at the treatment of the arms in the Degas. Up
at the top right corner, the arms of the standing woman holding

85

the cup are sharply outlined. Against them, and making a strong contrast, the upraised arm of the girl brushing her hair is very delicately drawn and hardly accented at all, till you come to her hand. This is rather more definite, and is a most beautiful piece of drawing, incidentally. The dark of the hair is given a strong emphasis, and then, moving over to the left, the bent arm is merely suggested, with hardly any accent at all. It is possible, I think, that Degas wanted to avoid an accent here, because it would form an uncomfortable triangle pointing at the edge of the paper. Or it might merely be still in an unfinished condition, of course (Degas was continually retouching these pastels). Whatever the reason, this subtle shifting from sharp to blurred plays an important role in the composition.

Try the effect of this in some picture of your own, perhaps in one that you feel has a certain dullness or hardness of quality. Loosen up some of the edges by painting across them, or scraping while the paint is still wet. By this means the shapes can be 'got moving' again. Now try to bring out what you consider to be important directions or rhythms by sharpening the accent on certain edges and forms.

Of course, a variety of accent is better arrived at in the course of building up the structure of the picture, either from nature or when using drawings and memory. The small landscape reproduced in colour opposite, by Diana Armfield, is a case in point. This was largely painted on the spot, and the very subtle shifts of emphasis are entirely arrived at as a direct response to visual experience.

This is also true of the way that rhythms and directions which link up forms in different parts of the motif can be discovered in the course of painting. Sometimes one starts a picture with a certain feature of the motif in mind, and discovers other aspects only while painting.

In this subject, for example, one might begin by being very conscious of the way the vertical cypress continues the line of the farmhouse wall downwards and cuts the oblique line of the path. In the course of working on the picture, one might begin to see how the left-hand side is rather severe and rectilinear, while the right-hand side is complex and soft in shape, and that the way that small verticals like the tree-trunks echo the main upright is of considerable importance.

Fig. 81 *Farm in Tuscany* by Diana Armfield

One could call this 'thinking with the brush in hand' and there
is no doubt that a reasonably slow tempo of work will give it a
better chance to develop creatively. Cézanne, of course, is the
supreme example of this. He would pause for quite long periods,
his brush ready poised, looking and searching. There is, in fact, a
story that when he and Pissarro were out painting together, a
peasant went up to Pissarro and said 'Sir, you've got an assistant
over there who isn't doing a stroke of work'.

Fig. 82 *Inside Greenhithe Chalk Pits* by Antony Kerr

Everbody knows what 'rhythmic' means in music; when used to describe visual phenomena it is not quite so easy to define. The dictionary calls it 'a measured flow of words and phrases' when applied to writing or speech, and perhaps this will do for our pictorial purposes as well. It certainly implies movement, and to some extent repetition.

This painting by Antony Kerr (fig. 82) has a dominating theme of a big and generous curving movement. It is stated in its most obvious form in the sweep which starts from the cliff on the left and descends towards the right-hand corner. This curve is taken up and repeated, in one form or another, all through the picture. See how many variations of it you can find. Sometimes it is upside-down and sometimes it is reduced to a comparatively-tiny size. Another big curve sweeps round into the distance.

The still-life by Henri Hayden (fig. 83) may seem deceptively simple. Actually it is a very sophisticated piece of composition, and I include it because it demonstrates two of the points I have

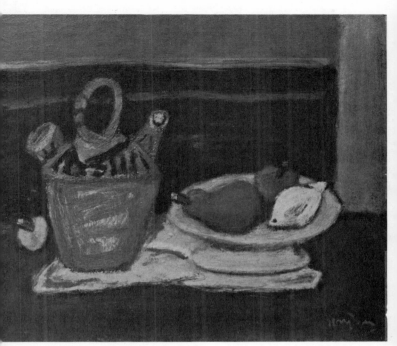

Fig. 83 *Nature Morte 1958* by Henri Hayden

already made. First, rhythmic echoing of shape: here there are no big connecting lines or rhythms, but instead a very subtle inter-play, in the forms themselves, between curved and pointed shapes. Almost every shape is rhymed with another — the handle of the jug by the rounded fruit, the upper part of the jug by the lemon, and so on.

Secondly, this is a very good example of the use of varied edges to give a feeling of changing emphasis. On the whole, the edge between one colour and another is full, and slightly blurred. In places this is sharpened by a more defined stroke, which draws a form or a part of a form more keenly. Let your eye move round the edge of the plate, and you'll see what I mean.

The same variation between sharp and blurred edges empha-sizes many of the linear directions in the Kerr landscape (fig. 82).

Finally, in the Hayden still-life, you will notice that the vertical division in the background comes exactly at the square of the rectangle (see p. 26, on rabatment).

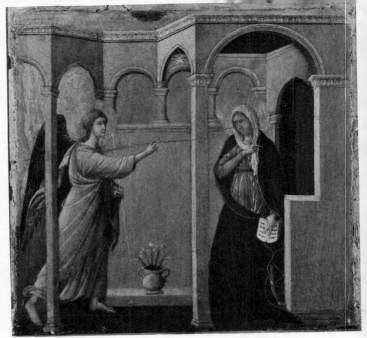

Fig. 84 *The Annunciation* by Duccio. National Gallery, London

Duccio's *Annunciation* (fig. 84) shows another aspect of the rhythmic construction of a picture which is, to me, as near as one can get to an equivalent to music in visual terms. Again one naturally 'reads' the design from left to right, and this is reinforced by the direction in which the angel is moving. As one's eye travels across the arches at the top of the picture, it is not too fanciful, I think, to see the connection between their grouping and a musical phrase — short notes and a long one, rising and falling (fig. 85).

This painting has such poetry and charm that it seems heavy-handed to analyze it further. I would like to point out, however, the way that the Virgin's cloak falls, on the right-hand side. From its long sweep downwards, echoing the curve of the arch above, it is gathered up by the hand holding the book, and then falls to the ground in the most elegant and varied curves. These are full

Fig. 85

Fig. 86 *The Battle of Boggarts* by Richard Eurich

of vigour and organic liveliness; in trying to think of similes for their curvature, one can be reminded of plant tendrils, waves or a whiplash.

Both fig. 86 and the one on the next page, though very different, are examples of a type of composition in which intense vitality is created by the use of small, lively units which work over the whole picture surface. The Eurich (fig. 86) has a definite framework; the onrush of these frantically-active shapes focuses on the gap in the hedge in the middle distance, and the whole design is held in place by the severe horizontals at top and bottom of the field. However, the aspect I want to concentrate on here is the way that a painting can be composed in terms of a scattering of units over the surface.

This can be found in many paintings by Brueghel and Bosch, as well as by modern non-figurative artists such as Mark Tobey. If a picture is largely composed of small units, they must have a certain liveliness and vigour, so that they can create tensions and energy by the way they move against one another. This will make up for the lack of larger forms and rhythms.

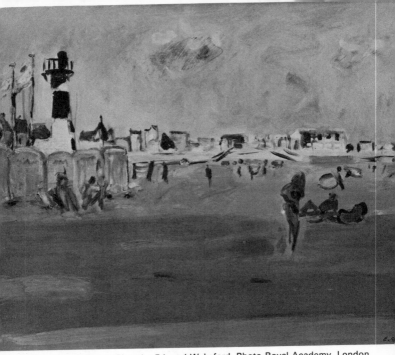

Fig. 87 *Quiberon Plage* by Edward Wakeford. Photo Royal Academy, London

This painting by Edward Wakeford (fig. 87) is rather different, in that its basis is a fairly-straightforward composition, rather along the lines of many Impressionist paintings. It belongs, in this respect, to a healthy tradition of paintings done on beaches — one thinks of Boudin, Monet, and Whistler, among many others.

The handling, however, is very different. The forms are drawn with extreme liveliness, and the marks that the brush makes in defining them begin to take on an importance of their own. These hastily scrawled and stabbed marks not only define bathers, huts and lighthouse; they also set up a dance of their own.

Lastly, I want to mention two pictures which both depend to a great extent on tonal massing.

Both these pictures, I should add, are also distinguished in colour; but they suffer less from a small monochrome reproduction than many others, because they use a strong and simple massing of dark, light, and middle-toned areas.

Look at the Daumier (fig. 88) carefully, and see how readily you can distinguish about four or five different tones, all of which

Fig. 88 *Woman and Children* by Daumier. Mesdag Museum, The Hague

Fig. 89 *Brecon Beacons* by Joanna Carrington

are used in definite masses. You could classify these tones as a
dark and a light, plus two or three middle tones. The whole of the
upper part of the woman carrying the baby, for instance, comes
into the light middle-tone category; the standing child in the
middle is made up of three tones – dark, dark middle, and light.
The sky makes a very satisfactory flat light shape. Follow the way
that it fits in between the heads of the woman and the tree, and
the way this light shape can be enjoyed as a shape in itself, and
not merely seen as a background.

Joanna Carrington's Welsh landscape (fig. 89) uses tone to
establish a mood, and again the range used is a very well-defined
one. In a key as low as this one, the dark shapes can be allowed
to link up in a way that creates bigger masses. One such can be
seen on the left-hand side of this painting, where the dark cloud
links with the mountain moving down towards the white cottage.
The connection continues into the foreground shapes in the
corner, and a very rich and vigorously-shaped mass is the result.

The light areas are also placed with a great deal of care. The

lightest note in the whole composition is the cottage wall, and this small, precise shape is linked by its diagonal roof-line to the shapes of the skyline behind it. It is also slightly more intense than any other white in the picture. A sky like this can, unless one is very conscious of the sort of shapes one is making, deteriorate into little more than sweeps of the brush. Look closely at the shapes that the clouds make here, and notice that every shape has been observed and thought out; there is none of the empty repetitions of shape that can so easily happen.

One of the most usual causes of disjointedness and lack of unity in a picture is a lack of connection between areas of tone. You can often help matters by consciously massing the tones more, by linking one area to another and bringing the tones into closer relationship (see p. 33). In fact, they are likely to be more closely related in nature. It is all to easy to misjudge a tone relationship slightly, often with the unconscious desire to achieve a brighter result, and end up with a jumpy and disconnected look.

Making connections, of this and other sorts, is, perhaps, the basic thing about developing a feeling for composition.

A note on perspective

Perspective is one of those subjects, like composition, around which a great deal of theory has gathered. Some of it is extremely difficult for the average painter or student to understand; but fortunately most of it is quite unnecessary, unless one is an architectural draughtsman or the sort of painter who needs to invent imaginary scenes full of pillars, staircases and chequered pavements.

The complex perspective needed to carry out this kind of thing comes into the category of knowledge which is better left alone until the time comes when it is actually inconvenient not to know it. Then, under the pressure of practical circumstances, as much as is necessary can be acquired.

Obviously, many beautiful and expressive pictures don't need any knowledge of perspective at all, such as the Persian miniature shown here (fig. 90).

Whether we use perspective or not, I am sure that some under-

Fig. 90 Persian miniature. Victoria and Albert Museum, London
(Crown Copyright)

Fig. 91

standing of it is necessary for a full grasp of painting. It can be defined as an explanation, using a certain set of assumptions, about how we see the natural world. Thus it helps us to make order out of our material and to understand it. Looked at like this, and taking into account the fact that it helps us to construct space in a picture, a grasp of the elementary principles of perspective is valuable, and has, I am sure, something to do with our subject of composition.

Notice, by the way, that I don't claim perspective to be 'only one way' or convention for representing nature, as is sometimes stated. It seems to me far more than this; it *uses* conventions, such as the fixed viewpoint, but it is hardly in itself a mere convention; rather a formularizing of the way that we apprehend the visible world. Of course, it can be altered at will, or disregarded — it simply forms one of the weapons in the painter's armoury.

The first assumption that we must make is that we are dealing with the roughly conical area that we can see clearly without moving the head. The angle of this may be defined as about 30 or 40 degrees (fig. 91). The other assumption is that everything is standing on a flat plane.

Elementary perspective can be reduced simply to whether lines slope, and how much. A drawing obviously 'out of perspective' is almost always judged to be so by the wrong angle of certain lines. The easiest approach is to take the simplest form of visual experience and see what we can make of it. Look at the room you

97

Fig. 92

are sitting in. Put yourself opposite a flat rectangular shape like a window or a fireplace. When I say 'opposite' I mean that an imaginary line drawn from your eye to the middle of this flat area would be at right angles to it; the 'line of sight', in fig. 91.

Now hold your pencil up against the horizontal lines of a window, as in fig. 92. There are several of them — the floor, the sill, the window frame, and the ceiling. You will find that they are all level, all horizontal, however much they are above or below you. This is our first principle then, that any horizontal line remains horizontal, if it is exactly opposite us, or at right-angles to our line of sight.

This brings in the second concept, the eye-level. This simply means the line which is level — the same height above the ground — with your eye. In fig. 92, it will be part of the window frame. If you stand up, or sit down, the eye level goes up or down too. Now, look round your room and decide which line is on your eye-level. Turn round, and look at another part; stand up, and decide where

Fig. 93

Fig. 94

the eye-level has moved to. The horizon, if you could see it, would always be on your eye-level.

Now look at a different part of your room. Here is a drawing of mine (fig. 93) just as it looks from where I am sitting. All around the room, at my eye level, a horizontal is established by the tops of canvases, the shelves, and the window sill.

Look very carefully at the lines which are above the eye level; for instance, the line of the ceiling or picture rail. These slope down towards the eye level, while similar ones below are sloping up. Judge the angle of all these sloping lines as accurately as you can, by holding up your pencil and estimating the slope against a horizontal and vertical, and then try to put down, very simply, the same angles on a piece of paper. You are now making a perspective drawing, whether you like it or not, and learning most of what you need to know about perspective at the same time.

To see how far we have come, let us try to invent an imaginary scene in perspective. This kind of exercise often turns out to be one of those scenes where things stand about on an endless plain (fig. 94). Still, this is quite a useful way to remind ourselves of the principles that we have been investigating.

Fig. 95

You will notice that there are people walking about in various parts of the plain, and one or two are sitting down on convenient stones. Notice that wherever these standing figures are, whether quite close or far away, their heads are all on a level with the horizon. This shows that you, the viewer, are also standing up. If you were sitting, the seated figures' heads would be on a level with your eye and with the horizon.

One of the packing cases is exactly opposite to us, its face at right-angles to our line of vision, and so all its lines are horizontal. The other is turned so that only the line at eye-level is horizontal; the others slope up or down.

So far I haven't mentioned scale – the relation between large things close to us, and small ones further away – but this is, of course, an important aspect of perspective. The relative scale of objects can, however, be easily determined. If we take one of the figures in our picture of the flat plain, and draw lines from his head and feet to the horizon (to make a change, I will assume that we are now sitting down), then any other figure can be placed in a convincing scale (fig. 95).

These very simple principles will probably be enough for the vast majority of thepictures we are likely to paint, when combined with observation. They will help you to compose, if need be, a fairly complex scene from memory. More important, they will help to check up where you go wrong in a painting or drawing from nature. As in composing a picture, however, the most important thing is to train the eyes. Get into the habit, whenever you are drawing, of checking the angle of sloping lines above and below the eye level with great care, and of deciding where your eye-level comes.

How does all this fit in with the various modes of composition that we have been discussing in this book? I think it is useful to consider some principles of perspective together with ideas about composition, because they form a convenient method of creating space in a picture; and anything that establishes space, and therefore scale, is bound to concern us to some extent.

The use of formal perspective, then, means that we get a logical difference in scale between near and far objects. But if our main concern is with the relationship of large forms seen as shapes against a background, as in the Persian miniature on p. 96, the adjustment or abandonment of perspective will become necessary. 'Accurate' perspective would destroy the point of this particular pictorial idea.

Often, as in Poussin (fig. 67) or Cézanne, perspective is not abandoned but is flattened to create a shallow space in which the forms can be closely related in a frieze-like way. The tendency of much modern painting has been to flatten the pictorial space in this way, and this is a logical step where the main motif of the painting is the organization of colour.

As with composition generally, the 'rules' of perspective need not concern us, except for a few specialized purposes. However, it is essential to be aware of principles, and to know something of the possibilities, in order to sharpen our perceptions.
This, really, is what matters. I said before that 'compositions are all around us' (and the same might be said of perspective). What we need to do is to learn to look, with an open mind and some understanding of the possibilities. There is then no need to get too involved with rules and formulae.

I am reminded of the composer Elgar who once said he felt that music could, so to speak, be 'plucked out of the air' around him. He always objected to the phrase 'composed by . . .' on the title-pages of his scores, saying 'this word always brings up a vision of a man scratching the back of his head with a pen — if I do scratch (which heaven forbid) it's not for ideas.'

However, it is only on a basis of knowledge that we can become free to compose naturally. The person who has never seriously looked at paintings will inevitably be very limited in the way he composes his own paintings. 'A little knowledge' means that we will often imitate other artists' ways of composing, but there is no harm in this — imitation is an essential part of the learning process. The whole aim of this book has been to make a rapid foray, so to speak, through the enormous range of possibilities that await us as soon as we start putting shapes down on to the two dimensions of a canvas.

For further reading

This list is merely a suggestion for further reading. Few of the books on it are specifically about composition, but all of them contain illuminating and stimulating material.

Elements of drawing by John Ruskin; Allen and Unwin, London; Reprint House International, New York

A free house by Walter Sickert; Macmillan, London

Ingres by R. Rosenblum; Thames and Hudson, London 1967; Harry Abrams, New York 1968

Modern painters by John Ruskin; Allen and Unwin, London

Painting lessons from the great masters by H. L. Cooke; Batsford, London 1968; Watson-Guptill, New York 1967

Picture making: technique and inspiration by Charles Sims; Seeley Service and Co., London 1934

Piero della Francesca by Sir Kenneth Clark; Phaidon, London 1969; Praeger, New York 1969

Seurat by John Russell; Thames and Hudson, London 1965; Praeger, New York 1965

Treatise on figure painting by André Lhôte; Zwemmer, London 1951

Treatise on landscape painting by André Lhôte; Zwemmer, London 1950

J. M. W. Turner, his life and work: a critical biography by Jack Lindsay; Cory, Adams and Mackay, London 1966; New York Graphic Society 1966

Vision and Technique in European painting by Brian Thomas; Longmans, London 1952

Acknowledgements

My thanks are due to the following artists and owners for permission to reproduce pictures in this book:

Diana Armfield fig. 81
Art Institute of Chicago fig. 73
Art Properties Incorporated fig. 75
Mrs Austin fig. 66
Joanna Carrington fig. 89
Courtauld Institute Galleries, London fig. 16
Richard Eurich RA figs 72, 86
Evening Standard and Peter O'Donnell fig. 2
Antony Kerr fig. 82
F. Kobler fig. 48
Mrs Dorothy Mahoney fig. 65
Mansell Collection, London fig. 4
Mesdag Museum, The Hague fig. 88
National Gallery, London figs 20, 23, 62, 63, 67, 70, 75, 77, 84
National Gallery of Scotland, Edinburgh fig. 71
M. François Pacquement fig. 26
Redfern Gallery, London fig. 86
William Roberts RA and d'Offay Couper Gallery fig. 76
Gilbert Spencer fig. 69
Tate Gallery, London fig. 79
Victoria and Albert Museum, London fig. 90
Edward Wakeford ARA fig. 87
Mrs W. Watson fig. 28

Index